YOU WILL BE ABLE TO DRAW

MANGA

BY THE END OF THIS BOOK

Thunder Bay Press
An imprint of Printers Row Publishing Group
10350 Barnes Canyon Road, Suite 100, San Diego, CA 92121
www.thunderbaybooks.com

For Ilex Press:
Publisher: Alison Starling
Editorial Director: Zena Alkayat
Commissioning Editor: Ellie Corbett
Managing Editor: Rachel Silverlight
Junior Editor: Stephanie Hetherington
Art Director: Ben Gardiner
Designer: JC Lanaway
Senior Production Controller: Allison Gonsalves

For Thunder Bay Press:
Publisher: Peter Norton
Associate Publisher: Ana Parker
Publishing/Editorial Team: April Farr, Kelly Larsen, Kathryn C. Dalby
Editorial Team: JoAnn Padgett, Melinda Allman, Dan Mansfield

ISBN: 978-1-68412-960-7

Printed in China

23 22 21 20 19 1 2 3 4 5

YOU WILL BE ABLE TO DRAW

MANGA

BY THE END OF THIS BOOK

LAURA WATTON

THUNDER BAY
P·R·E·S·S
San Diego, California

CONTENTS

CHAPTER 1
DRAW FACES

CHAPTER 2
CREATE A CHARACTER

WHAT DO YOU WANT TO DRAW TODAY?

STEP-BY-STEP PROJECTS

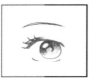
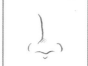
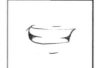
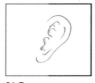

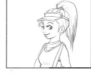

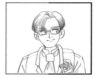

DRAWING PEOPLE

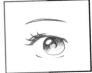 17 Eyes

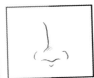 18 Noses

 20 Mouths

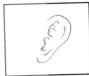 21 Ears

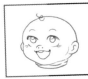 22 Head Proportions

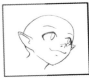 24 Portrait Angles

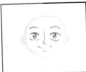 28 Expressions

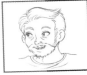 30 Hair

 35 Drawing a Body

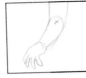 36 Arms

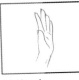 37 Hands

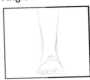 38 Legs

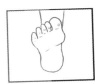 39 Feet

 42 Baby, Child, Teenager & Adult Bodies

 50 Chibis

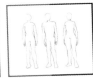 54 Body Types

 87 Poses

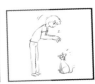 88 Stance & Motion

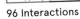 96 Interactions

WHAT DO YOU WANT TO DRAW TODAY?

DRAWING ANIMALS & OBJECTS

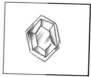

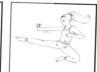

CREATING A CHARACTER

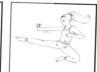

MARK-MAKING & EFFECTS

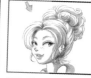

BUILDING A STORY

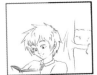

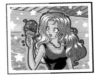

INTRODUCTION

IS MANGA A GENRE?

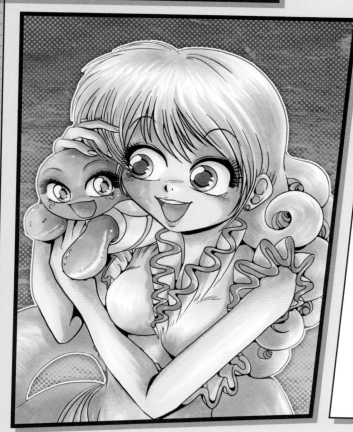

Manga itself is not a genre. In the West, "manga" was originally used as a marketing term to separate comics that came specifically from Japan. However, it is now commonly used to describe comics drawn by artists that have taken on a distinct influence from Japanese comics. It also describes a specific style of artwork and storytelling.

In Japanese bookshops, manga is called "kommikusu" (comics), so the term "manga" is interchangeable with "comics," purely by preference.

Sports manga, romance comics, cooking manga, superhero comics—these are genres.

Originating in Japan, manga is a hugely popular and versatile style of pop-cultural illustration. It can be used in a wide variety of formats, from comic strips, illustrated books, and traditional long-form manga (graphic novels) to anime (Japanese animation) and fashion design. It can also make the perfect personalized gift for friends, family, and anyone who will appreciate your stories.

This book will teach you everything you need to know to start drawing your own colorful and energetic manga.

IT IS WORTH NOTING THAT THE GUIDANCE IN THIS BOOK MERELY AIMS TO PROVIDE SOME IDEAS, WHICH YOU CAN THEN TAKE AND MODIFY AS YOU LIKE.

RULES OF MANGA

Don't worry about the rules of drawing manga. Manga is a visual language, so enjoy it and have fun working with it. Have the confidence to experiment!

There are rules to help contain the "essence" of manga within your work, but do remember that rules are made to be broken, once they have been learned.

MANGA ANTHOLOGIES

In Japan, manga anthology magazines are published in print weekly, bimonthly, or monthly for a very low price. This enables publishers to present many different types of stories to audiences. It also means that audiences are exposed to new and different stories within each anthology, which they may not have picked up individually.

Western comic anthologies that have contained translated manga include *Raijin Comics*, *Super Manga Blast*, *Mixx Zine*, and *Shojo Beat*. Currently, the most well-known anthology is *Shonen Jump*, which is available in many countries worldwide via the *Shonen Jump* app.

Popular weekly and monthly anthologies available in Japan include *Manga Goraku*, *Big Comic*, *Shonen Sunday*, *La La*, *Ribbon*, *Hana to Yume*, *Nakayoshi*, *Shonen Gangan*, *Bessatsu Margaret*, *Betsucomi*, *Ciao*, *Jump SQ*, and *Korokoro*.

You can find manga anthologies online, so pick up a copy to see a vast array of manga stories and styles within one publication.

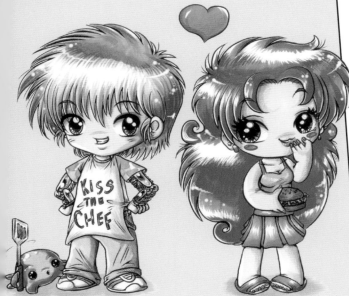

HOW TO USE THIS BOOK

This book will guide you in your artistic development, starting with simple exercises such as drawing your first characters, and working up to creating whole scenes and compositions using familiar manga-style themes. Each new subject offers space for you to practice and hone your skills. There are also plenty of tips and tricks along the way to help you make your manga more refined and professional.

FEEL FREE TO COPY SOME OF THE ILLUSTRATIONS IN THIS BOOK ONTO A FRESH SHEET OF PAPER TO CONTINUE EXPERIMENTING WITH DIFFERENT DESIGNS.

4. **Set the Scene** looks at movement, stances, and character interactions. There is guidance on creating suitable environments in which to place your characters. You will also find advice on the range of speech bubbles and background graphics that you can utilize to convey different types of emotion, drama, and impact.

1. **Drawing Faces** covers all the facial features, including eyes, noses, mouths, expressions, and hairstyles.

2. **Create a Character** explores how to create full-figure characters of all ages, from babies to adults. It also describes how chibis differ from children. It also looks at how to draw clothing that will reflect each character's personality, and it covers the creation of school characters, villains, fantasy characters, and martial arts characters to expand upon potential story concepts.

5. **Tell the Story** covers the steps to follow to get your stories published. This section aims to demystify the production process so that you can feel confident in bringing your manga to life, and ultimately swap, share, distribute, and sell your manga.

3. Also included in Chapter 2 are animals for use as pets and familiars. This covers drawing cute and cartoonish creatures, and realistic depictions for more serious manga stories.

Finally, at the back of the book, you'll find a troubleshooting section, extra tips and resources, and a glossary of key terms.

With all of these sections covered, you can feel confident and ready to take the next step toward drawing your very own manga.

Creating manga is a rewarding, enjoyable hobby, and can develop into freelance income for many artists. Some people make money from their work, others do it just for fun—many do both! Selling, making, swapping works, and trading art is a community-based practice as much as it can be a solitary one. Make it whatever you wish!

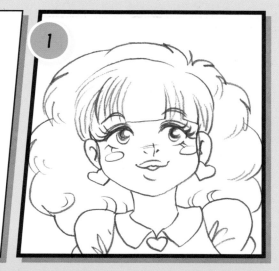

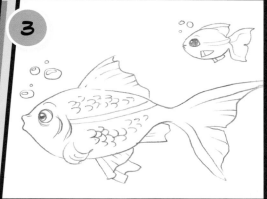

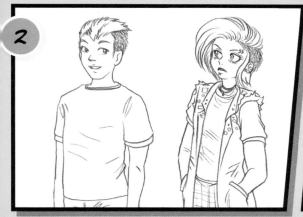

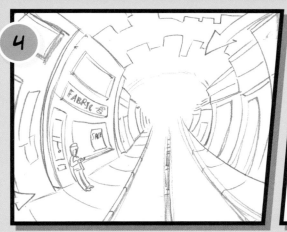

IT'S BEEN SIX WEEKS BUT TODAY'S THE DAY.

THE GOODBYE DAY.

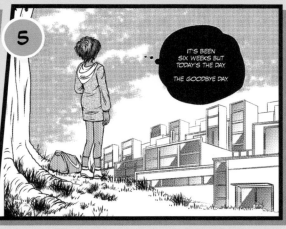

GETTING STARTED

Remember that your illustrations do not need to be perfect. Even if your pictures don't always match up with the visual that's in your head, just getting ideas down on paper is a great way to start. There will always be critics, and your inner critic can be the harshest of them all. Remember that learning is an ongoing journey. Practice makes perfect! By creating new work, your illustrations will naturally improve over time, so try not to get stuck in a cycle of redrawing imperfect ones.

There is no one correct way to draw manga, and there is a range of styles in this book that you may want to adapt to help develop your own particular way of drawing manga.

Styles change and, in order to follow new trends, even the most long-running manga artists might change the way they draw characters each time they launch a new series.

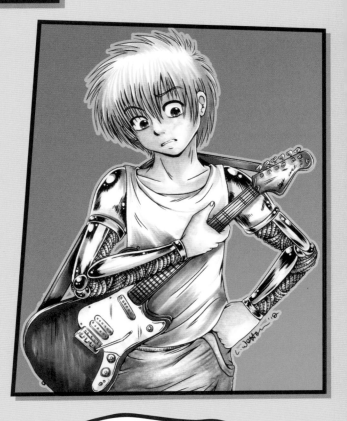

YOU DON'T NEED A HUGE COLLECTION OF MATERIALS TO DRAW MANGA. HISTORICALLY, COMICS WERE CREATED USING VERY FEW AVAILABLE MATERIALS.

IT IS GOOD PRACTICE TO START SMALL AND GROW YOUR COLLECTION OF MATERIALS AS YOU BUILD YOUR BODY OF WORK AND ARTISTIC ABILITY, ESPECIALLY BEFORE SPLASHING OUT ON VERY EXPENSIVE EQUIPMENT. CONFIDENCE CAN ONLY BE DEVELOPED, NOT PURCHASED.

I HOPE YOU FIND THESE EXERCISES FUN AND INSPIRING, AND I'M LOOKING FORWARD TO SEEING YOUR MANGA ONE DAY, TOO. SHARE YOUR CREATIONS WITH ME USING:

#DRAWMANGABOOK

LAURA WATTON

Blue non-photo pencils are great for quickly drawing a rough structure onto paper. "Non-photo" means the color does not show up when photocopied, and can easily be erased with some digital adjustment when scanned. It eradicates the need to rub out black pencil lines, and so it speeds up the process of drawing and creating, as well as lessening the risk of scrunching up your paper when rubbing out pencil.

Soft pencils (3B–9B) are good for delivering bold, energetic lines and allow you to draw more quickly.

Hard pencils (9H–2B) give you a sharp line for longer, which is good for making sketches and drawing details. Their lines are also light and easy to rub out.

Mechanical pencils deliver the same width of line consistently, with no sharpening needed, which reduces interruptions when drawing.

Fineliners are predominantly used to ink over pencil work when drawing manga. They come in different widths and textures. The width of the line is consistent, which is good for certain styles of comic. Variations in line widths can then be built up in stages.

Dip pens were the main pens used to ink comics before fineliners were invented. Dip pen nibs give a wide variety of line widths and are still preferred by a number of comic artists today.

Brush pens are a neater option than using a traditional sable brush and ink pot. Brush pens are transportable and less messy (the ink is in cartridges).

YOU MAY ALSO NEED

- Plastic rulers
- Triangle rulers (also called set squares)
- White eraser
- Eraser pen
- White correction fluid
- Pencil sharpener
- Comic book paper, with preprinted blue ruler measurements
- Photocopy paper (70gsm+)
- Spiral-bound sketchbook (90gsm+ paper)
- Large LED lightbox/light screen
- Alcohol-based, rubber-tipped, and chisel-tipped markers
- Bottled ink (including white ink)
- Watercolor paint
- Paintbrushes (white acrylic and sable ink brushes recommended)

DRAW FACES

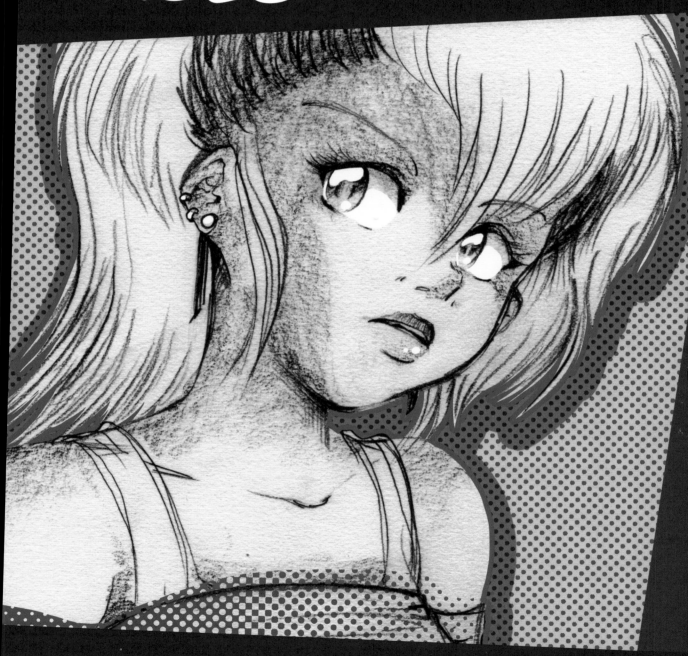

EYES

The eyes are the window to the soul, and this is especially true in manga. Most of us recognize huge, expressive eyes as a trait specific to this art form. Influenced by pre-World War II animations from America such as *Bambi* and *Betty Boop*, Japanese comic artists began to draw their heroes and heroines with similarly large eyes.

There are many different eye types and styles in manga. The most common structure of the eye is a thick line at the top, complete with eyelashes, and a thinner line for the bottom rim. There is usually space between the top line and the lower line of the eye so that the lines are not joined. Artists often use exaggerated eyelashes to make eyes look more feminine. Complete the eye with a circular or oval iris, with a light glint at the top, the pupil inside, and shading that runs from dark to light from top to bottom.

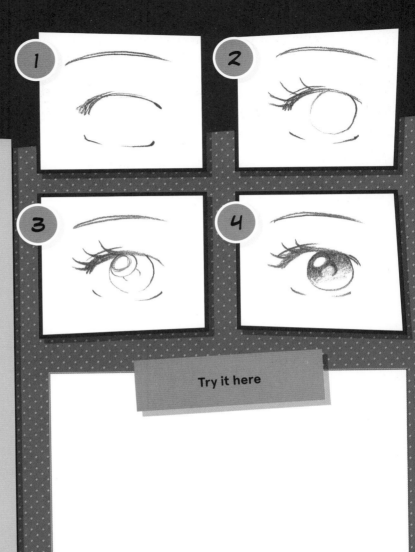

Try it here

NOSES

Different styles of noses suit different characters. Here is a selection of noses, showing a range of shapes and styles in varying degrees of complexity, from broad and rounded to small and pointed.

The simplest style of nose is the smallest, sometimes depicted with just a dot or a line to hint at its shape. The smaller the nose, the bigger the emphasis on the eyes.

Older characters tend to have fairly proportional facial features. Generally, the cuter the character, the smaller the nose and the bigger the eyes will be. Sometimes, a character might even have no nose at all!

The most common style of nose features a triangular or circular tip, shading with some small dash lines, and a short bridge line. Noses can be sprinkled with freckles, and dash lines can be used on noses and cheeks to emphasize cuteness.

SMALL AND SIMPLE

LARGE AND DETAILED

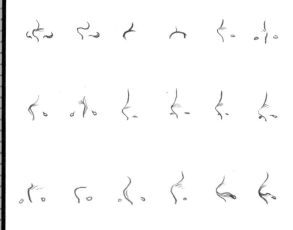

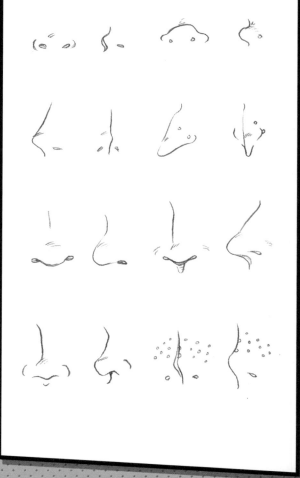

TAKING NOTE OF PEOPLE'S FEATURES WILL HELP YOU DRAW DIFFERENT TYPES OF NOSES, EYES, AND LIPS. PRACTICING DRAWING THEM HELPS TO STORE THEM IN YOUR MUSCLE-MEMORY BANK, SO THE MORE YOU PRACTICE, THE LESS YOU'LL NEED TO USE A REFERENCE.

MOUTHS

As with eyes and noses, there is a great range of styles for mouths that will suit different character types.

Three manga-specific types of mouth include the cute bean-shaped mouths, with no or few corners (A); elegant lips with a cupid's bow (B); and rounded mouths with points, almost like a combination of the first two (C). Teeth are not drawn with much detail, they are usually just depicted as white areas, unless your character is monstrous (see page 73).

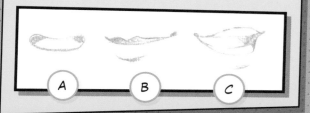

A B C

1

2

3

Try it here

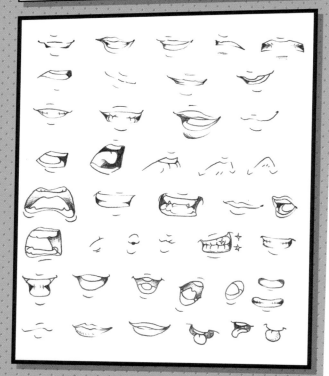

EARS

An easy way to draw ears is to draw a bean shape with a mark inside that looks like the number 3. This technique is great for quick and cartoonish characters. For a more detailed look, add shading behind the curves.

Decorations such as piercings and ear cuffs add character, and pointed ear tips work well for otherworldly types.

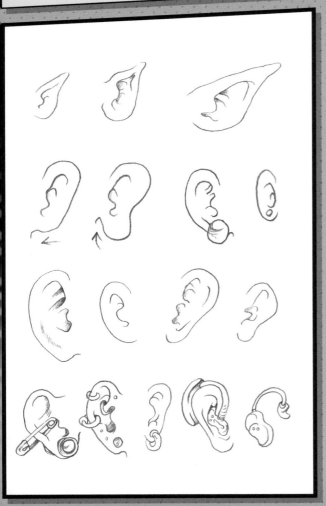

Try it here

HEAD PROPORTIONS

Much like different facial features, face shapes and head proportions can hint toward each character's age and demeanor. Facial features can be emphasized or understated as much as desired. For example, an enthusiastic character may have energetic, exaggerated features, such as a large mouth and wide eyes.

The skull needs to host the manga character's features proportionally. Typically, the eyes are set halfway down the front of the face.

Here, I've shown you different views for different angles of the face—three-quarter, side profile, and front view. The angle affects the positions of the features; for example, for a side view you will draw the front of the eye near to the nose and not the ear.

The proportions of the head will vary depending on the age of the character, as well as the size in comparison to the heads of older or younger characters within the same panel.

SOMETIMES MANGA ARTISTS HAVE TRADEMARK FACE SHAPES THAT ARE OFTEN REFLECTIVE OF AN ERA. FOR EXAMPLE, IN THE EARLY 1990S, MANY OF CLAMP STUDIO'S CHARACTERS HAD VERY ELONGATED, TRIANGULAR FACES. IN THE LATE 1990S, SOME DESIGNERS GAVE CHARACTERS IN THREE-QUARTER VIEWS WITH BULGING CHEEKS, WHEREAS THE MOST COMMON STYLE AT PRESENT IS FOR CHARACTERS TO HAVE MORE SMOOTHED-OUT FACES WITH REDUCED CHEEK CONTOURS AND LOWER-SET MOUTHS.

FACE SHAPES

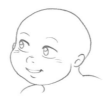
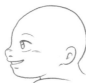
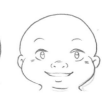

Baby

Child

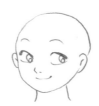
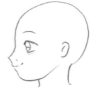
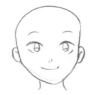

Teenager

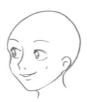
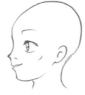
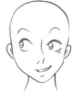

Adult

PORTRAIT ANGLES

The most common portrait angles (head-and-shoulder crops) include the profile view, side view, and three-quarter view (as shown on page 22). However, these aren't the only possible orientations—manga would be very boring if they were! Take this opportunity to play around with the other angles you can draw.

Here are some illustrations showing how and where to place facial features depending on the angle of the head.

A SIMPLE REFERENCE TECHNIQUE IS TO BUY SOME CHEAP TABLE-TENNIS BALLS AND DRAW GUIDELINES AROUND THEM WITH A PERMANENT PEN. WHEN YOU TURN THE BALL TO DIFFERENT ANGLES, THE LINES WILL SHOW YOU WHERE THE FACIAL FEATURES SHOULD BE PLACED.

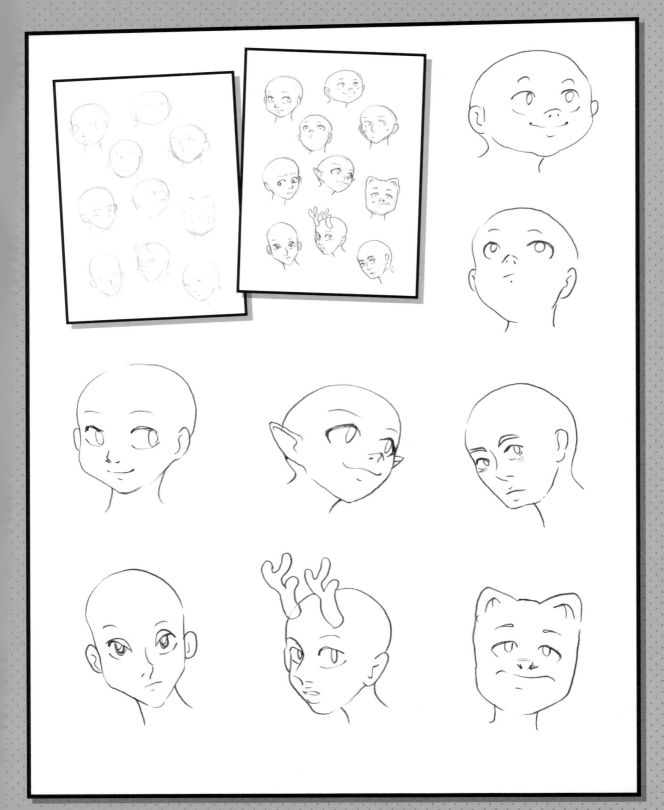

WHEN YOU ARE DRAWING COMICS, YOU WILL HAVE TO DRAW A CHARACTER MULTIPLE TIMES IN VARIOUS POSITIONS, SO PRACTICE WILL BE REQUIRED TO KEEP THEM RECOGNIZABLE FROM ALL ANGLES.

TRY CREATING A ROTATING HEAD SHOT. TAKE A NOTEBOOK WITH THIN PAPER AND START AT THE BACK OF THE BOOK. DRAW A FACE IN A SIDE PROFILE VIEW. ON EACH NEW PAGE, TRACE OVER THE DRAWING ON THE PREVIOUS PAGE, ROTATING THE HEAD JUST A LITTLE.

THIS IS A COMMON ANIMATION TECHNIQUE; ONCE FINISHED, YOU CAN FLIP THROUGH THE PAGES TO SEE MOVEMENT.

EXPRESSIONS

Expressions are most easily conveyed through the facial features of your characters. Eyes and eyebrows interact to portray different emotions, and turning the lips up or down will show smiles, frowns, and other expressions. Use of line can also convey your character's feelings. For instance, a wobbly line for a mouth or brow can indicate uncertainty.

Manga expressions can be regular or exaggerated (e.g., happy or ecstatic), depending on the situation or your character's personality. Take a look at your favorite books to see how they depict different characters and their expressions.

Animators and cartoonists often use a mirror to look at themselves pulling faces to get the gist of an expression. You could also use a mirror or take a series of selfies to help you draw your own expressions. Alternatively, ask someone to model for you.

EXAGGERATED EMOTION MARKERS:
HAPPINESS = LINE BEAMS
SADNESS = TEARS
ANGER = FURROWED BROW, ANGER VEINS
WORRY = SWEAT DROPS, WOBBLY LINES
RELIEF = EXHALING OF AIR
PEACEFULNESS = SMALL GLEAMS OF LIGHT
DOUBT = LINES AND QUESTION MARKS

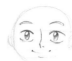

HAPPY

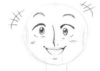

ECSTATIC

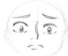

SAD

DISTRAUGHT

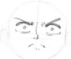

ANGRY

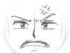

ENRAGED

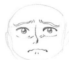

WORRIED

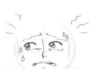

DESPAIRING

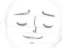

RELIEVED

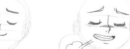

EXTREMELY RELIEVED

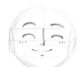

PEACEFUL

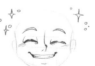

ENLIGHTENED

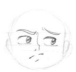

UNSURE

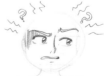

SUSPICIOUS

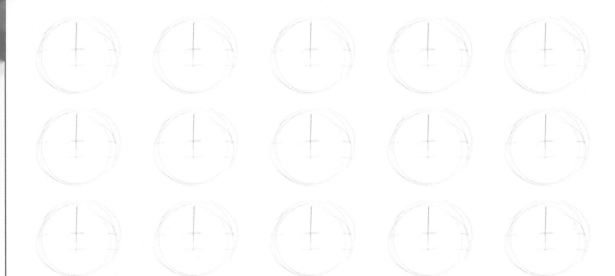

HAIR

Voluminous hairstyles are a popular feature of manga, used for further characterization. Many characters have spiked hair, intended to reflect their energetic demeanor, while calmer characters may have gentle flowing locks, and bubbly characters may have rounded, bouncy curls.

You will often find that just an outline of the hair is enough to imply a specific style. This simplified way of depicting hair is quick to draw and easy to memorize and repeat across panels.

A more complex way to draw hair manga-style is to study different hairstyles in real life and note how hair grows from the scalp and parts in different ways. Adding extra lines helps to depict the flow of where the hair parts and settles. This can also add volume and texture. Naturally, this approach takes longer than drawing an outline of a hairstyle, but is a great way to add detail and texture into your illustrations.

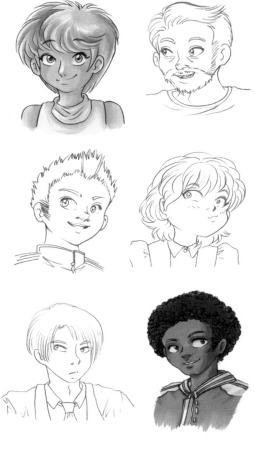

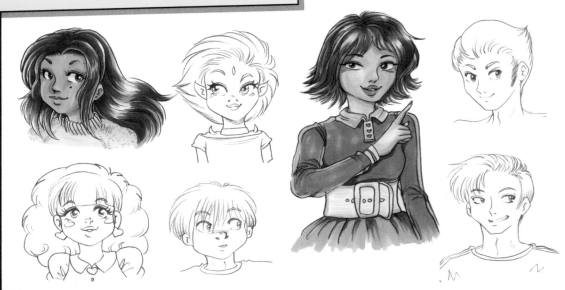

HOW TO DRAW HAIR

1. Draw your manga head, then add a line for your reference to show where the length of the hair will extend to.

2. For short hair, draw hair growing up and slightly out from the sides and front of the head. For long hair, or straight (not spiked) hair, draw the hair up and out from the hair parting, then down to where the bangs or length will be.

3. For short hair, add more detail to the hair and any extra features like sideburns and bangs. For long hair, draw downward further, demonstrating the flow of the hair over the shoulders.

4. Add final details to the hairstyle, such as more hair spikes or layers and hair strands.

IF YOUR CHARACTER HAS LONG HAIR, GRAVITY WILL AFFECT THEIR HAIR'S DIRECTION. UNLESS YOUR CHARACTER IS MOVING QUICKLY, THEIR HAIR SHOULD BE POINTING TOWARD THE GROUND. TAKE CARE TO DEPICT THE HAIR FALLING AT THE CORRECT ANGLE, FOLLOWING THE ANGLE OF YOUR CHARACTER'S HEAD.

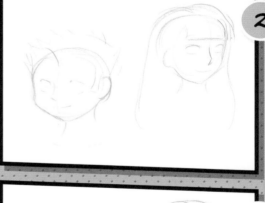

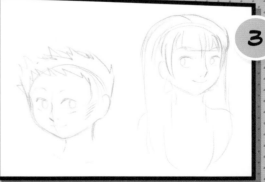

TO ADD HIGHLIGHTS TO HAIR, CONSIDER THE LIGHT DIRECTION AND USE ONLY LIGHT COLORS ON SOME PARTS, OR JUST DON'T ADD COLOR TO THESE AREAS AT ALL. THIS HELPS GIVE YOUR CHARACTER'S HAIRSTYLE VOLUME.

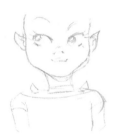

PRACTICE DRAWING HAIRSTYLES THAT CONVEY THE PERSONALITY AND EMOTION OF EACH CHARACTER. IT DOESN'T MATTER IF YOU HAVEN'T YET FINE-TUNED YOUR CHARACTER'S PERSONALITY BEFORE YOU BEGIN DRAWING, AS SOMETIMES YOUR INITIAL DESIGN MAY INFLUENCE THE OUTCOME OF THEIR PERSONALITY.

CULTURAL TERMINOLOGY MAY DIFFER, BUT HAIRSTYLES ARE UNIVERSAL! THE TERM "BANGS" IN THE UNITED STATES IS "FRINGE" IN THE UK; THE JAPANESE WORD FOR "BUNCHES" OR "PIGTAILS" IS "TWINTAILS." "PLAITS" ARE THE SAME AS "BRAIDS," WHILE "PONYTAIL" SEEMS TO BE UNIVERSAL.

TAKE A LOOK AT FASHION VLOGGER HAIR VIDEOS ONLINE FOR INSPIRATION, AND LOOK TO THE PAST TO SEE WHAT HAIRSTYLES WERE POPULAR IN DIFFERENT TIME PERIODS.

CHAPTER 2
CREATE A CHARACTER

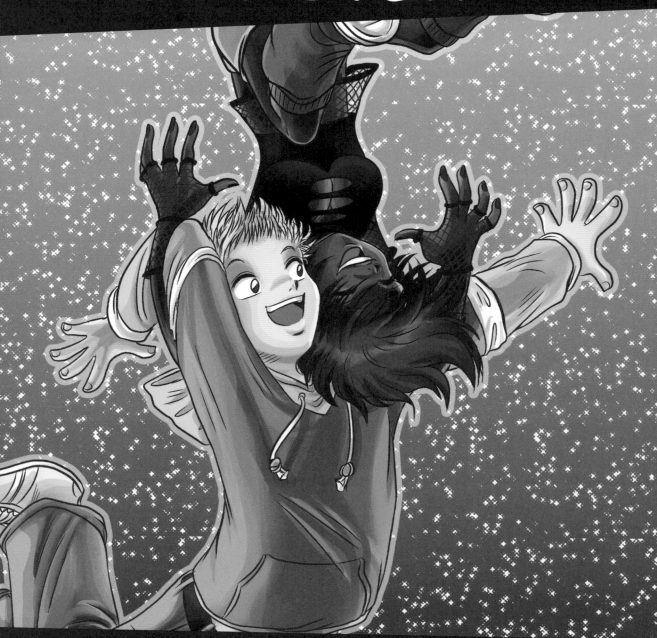

DRAWING A BODY

Before you start designing a character, it is important to establish the correct proportions for the body. To do this, you can use a series of identically sized circles as a basis to structure your character around.

Each circle represents the size of the head of your character, and this unit is used to measure how many circles are needed for the body. The number of circles will depend on the character's age and height.

This method has been used by artists for centuries. Leonardo da Vinci's *Vitruvian Man* is an early example of geometry being used to depict the proportions of the human body.

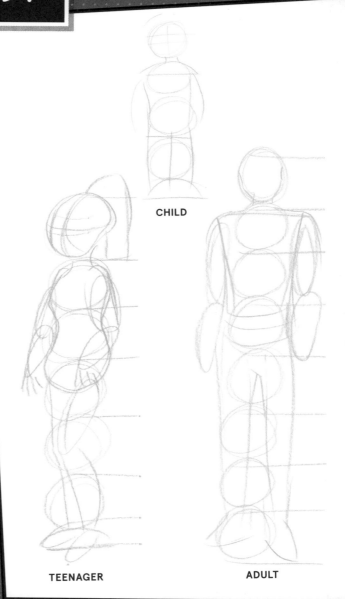

CHILD

TEENAGER

ADULT

ARMS

On this page are examples of how arms are constructed—mainly using ovals with circles for shoulders and elbows. Here, I have marked an "X" where the arms fold.

The younger the character, the shorter their limbs will be. The more muscular the character, the more rounded their limbs and the larger their shoulders will be.

REMEMBER THAT NOT ALL OF YOUR CHARACTERS WILL NECESSARILY HAVE TWO HANDS OR TWO FEET, OR HAVE THE SAME PHYSICAL ABILITIES AS OTHERS. CONSIDER THE DIVERSITY OF YOUR CAST AND THINK ABOUT HOW YOU WOULD REPRESENT A PERSON WITH A PHYSICAL DISABILITY.

HANDS

Hands represent gestures and expressions as well as functionality. For example, if your character is happy, their fingers may be splayed out. If your character is angry, their hands could be clenched tightly. If your character is holding a takeout coffee cup or drinking from a mug, their hands will look different than if they were drinking tea from a porcelain cup.

Children's hands should have stubbier fingers and smaller fingernails, whereas elderly fingers will often have slightly bigger knuckles, as well as lines to denote their age.

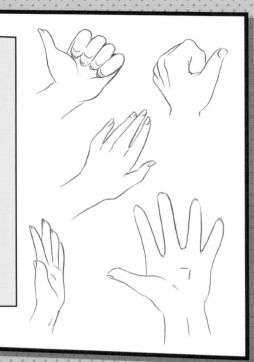

DRAWING ARMS AND HANDS

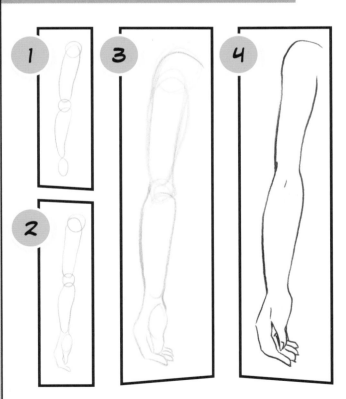

1. Draw two circles, one each for the shoulder and the elbow, and an oval for the hand. Connect them with two long ovals for the forearm and upper arm.

2. To draw a side-on view of the hand, draw a loose "Y" shape for the thumb and some straight lines to represent the outside of the index finger, knuckle, and a finger bend, like half a hexagon.

3. Add three other fingers behind the index finger, and add lines connecting the outside of the upper and lower arm, and around the shoulder.

4. Go over your arm in pencil, adding clavicles, indents to denote the inner elbow, and nails. If your character's arm or elbow is pressing against material, remember to add some creases to the fabric.

LEGS

Legs are drawn similarly to arms, but are a bit longer and wider. Again, mainly long ovals are used, with a circle for the knee. The more muscular the knee, the wider the oval. When knees bend, the mass is visually larger than it is when elbows bend.

Practice drawing basic characters with bent legs to get used to how each limb should be angled before attempting more detailed sketches.

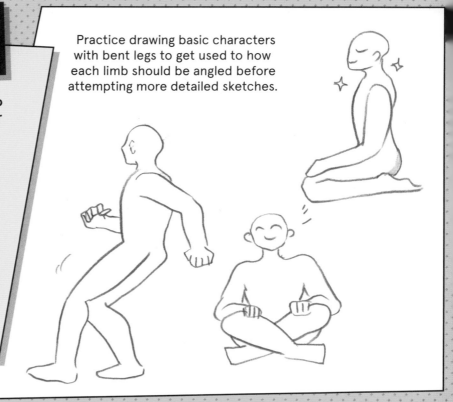

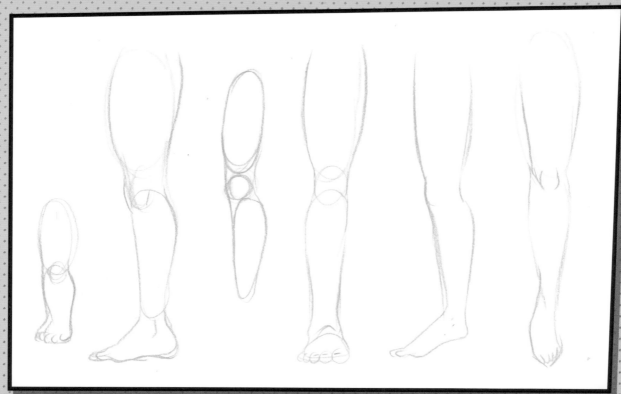

FEET

Although bare feet are not usually on show, understanding the foot's structure on its own is just as important when you are drawing shoes (see page 59).

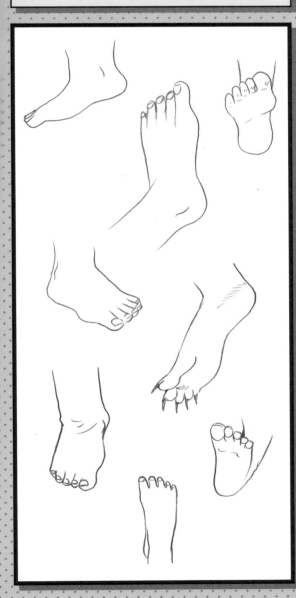

DRAWING FEET

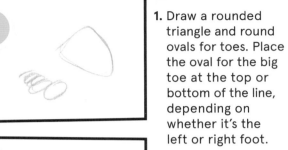

1. Draw a rounded triangle and round ovals for toes. Place the oval for the big toe at the top or bottom of the line, depending on whether it's the left or right foot.

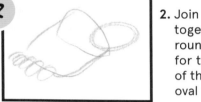

2. Join the elements together with a rounded rectangle for the main area of the foot, and an oval for the heel.

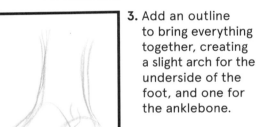

3. Add an outline to bring everything together, creating a slight arch for the underside of the foot, and one for the anklebone.

4. Now go over your sketch in pencil, tidying it up with confident lines.

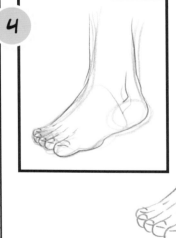

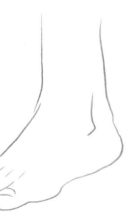

PLAY AROUND WITH ACCESSORIES—
YOU COULD ADD JEWELRY, TATTOOS,
PAINTED NAILS, BRACELETS,
OR A WATCH (SEE PAGE 62).

USE YOUR OWN BODY AS
A REFERENCE, EITHER FROM LIFE
OR A PHOTO, OR ASK SOMEONE
ELSE TO MODEL FOR YOU.

BABY, CHILD, TEENAGER & ADULT BODIES

To draw a body, use the circle technique outlined on page 35, where the size of each circle represents the size of the head. You could use three circles—one for the head and two for the body—for a very young child or toddler. For a primary school-aged child, you could use roughly four and a half circles—one for the head and three and a half for the body. Teenage and adult bodies are generally constructed from around seven to ten circles.

The height of the character, and so the number of circles used for the body, will depend on their age and physique—a model will likely be taller than an elderly person—so consider these characteristics when thinking about how tall they should be. Remember that you can use a half-circle measurement as well for smaller differences in height.

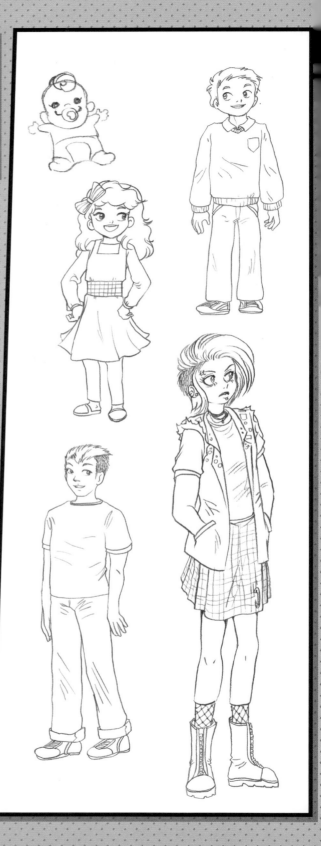

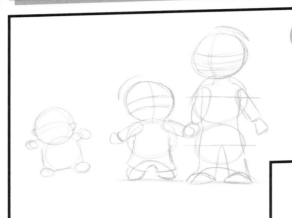

1. Draw between two and three circles, one on top of the other. The top circle can be slightly larger, as children's heads are proportionally bigger than an adult's.

2. Complete the baby's facial features with reasonably proportioned eyes, a button nose, cupid bow lips, and a curl of forehead hair. Toddlers will have more hair, slightly longer limbs, and larger eyes.

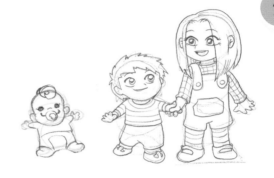

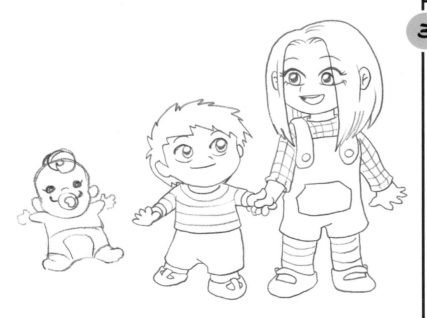

3. Add in extra detail to define the clothes, hands, and strands of hair. The fingers should all be pudgy—the cuter the better!

DRAWING CHILDREN

1. To map out a child's proportions, first draw four and a half circles.

2. Now add lines for the arms and legs. Arms and hands are one and a half circles in length, starting from the shoulders. The legs and feet are also one and a half circles long.

3. Begin to add in details like clothes and facial features very lightly, and you will start to see your character form.

4. Add further details to the clothing, hair structure, hands, and feet.

5. Now go over and refine your sketch in pencil. Add final details such as creases to the clothing and the shoe design.

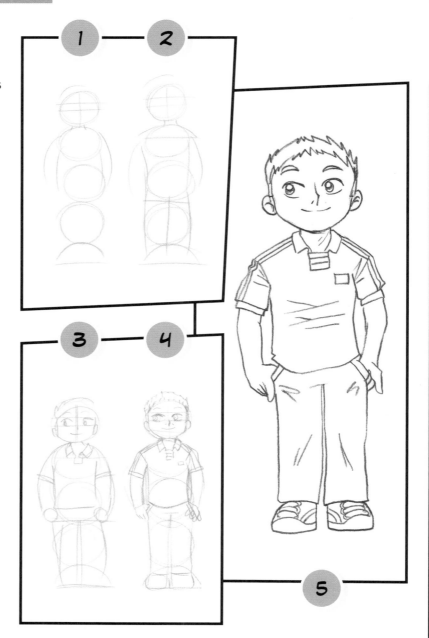

DRAWING TEENAGERS

1. To define a teenager's proportions, first draw six and a half circles. Then use ovals and lines to roughly place the torso, limbs, hands, and feet.

2. Go over your sketch to refine your shapes. In this pose, the character's arms are bent, so the hands stop at the hip, two and a half circles down. If this character had their arms straight down by their sides, their arms would be three circles long. Their legs and feet are three and a half circles tall.

3. Add in some extra details very lightly. As well as clothing and hair, in this sketch, I have started to add accessories.

4. Continue to add details to the clothing.

5. Go over your sketch in pencil. When penciling your character, you can add creases to clothing and final details such as visor piping, sock elastic, shoe details, and any other design elements.

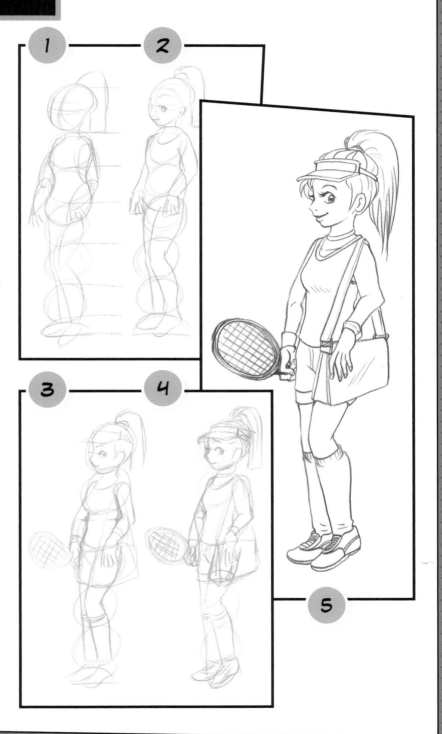

DRAWING ADULTS

1. To define an adult's body proportions, first draw eight circles. Then use ovals and lines to roughly place the torso, limbs, hands, and feet.

2. Go over your sketch to refine your shapes and start to add in some details very lightly. In this pose, the character has their arms down by their sides, therefore their arms are three circles long with their hands sitting within the fourth circle. Their legs and feet are four circles tall.

3. Continue to refine the clothes and add the hair.

4. Add accessories such as glasses, and refine the details on the clothing.

5. Go over your sketch in pencil. You can add creases to clothing and final details such as clothing seams, shoe details, and any other additional design elements.

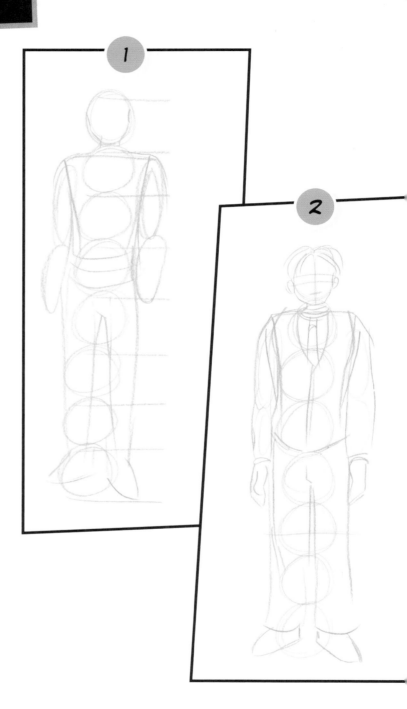

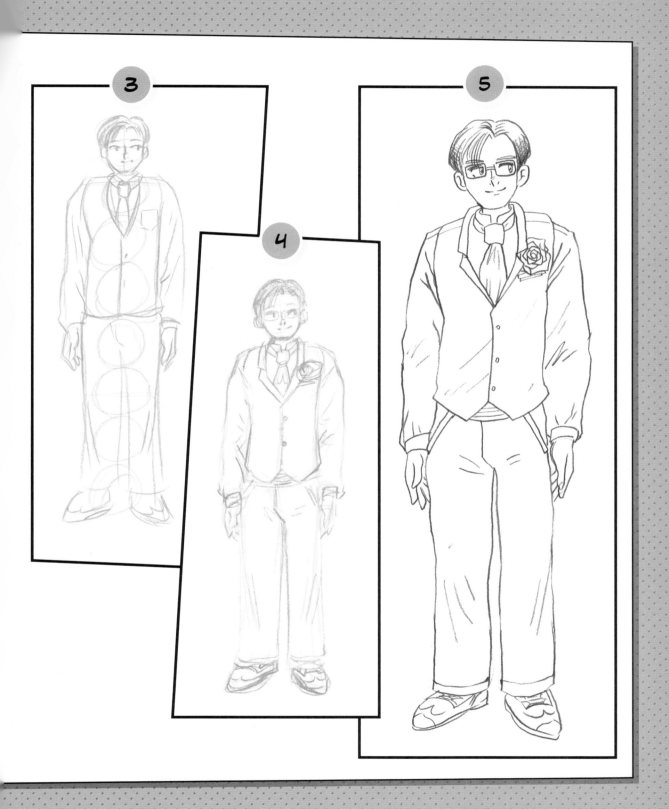

Practice here

IT'S HARD SOMETIMES TO
REMEMBER WHERE ELBOWS
AND KNEES SIT, SO IT IS WORTH
CHECKING ON YOURSELF, OR
GLANCING AT OTHER PEOPLE NEARBY.

AS A GENERAL RULE, ELBOWS BEND
JUST ABOVE THE HIP AND TIPS OF
FINGERS STOP APPROXIMATELY
HALFWAY DOWN THE THIGH.

CHIBIS

"Chibi" is the Japanese pronunciation of the letters "C" (pronounced "chee") and "B" (pronounced "bee"), which stand for "child body." Chibi characters are not actually children, the name just refers to the smaller proportions of the body—a chibi is a very cute depiction of a character with an exaggerated large head and a tiny body.

Chibis are rounded, cartoonish, baby-faced characters. Sometimes they represent a cartoon version of a more serious character (one with correct proportions and more mature storylines). This was (and occasionally still is) a fun way to add some comic relief to a very serious storyline, sometimes inserted as a short four-panel comic strip after a longer drama. This can introduce your more complex story to new audiences as well, as a chibi can be quite eye-catching and the reader may then wish to know more about them.

CHIBI CHARACTERISTICS

Chibis usually have huge eyes, very tiny noses (sometimes omitted altogether), a huge head, and similarly stylized hairstyles. Their actions and expressions can be exaggerated, adding to the humor of these cartoonishly stumpy and chubby characters. You could add sweat drops of exasperation, movement lines, happy lines radiating from their faces, and so on.

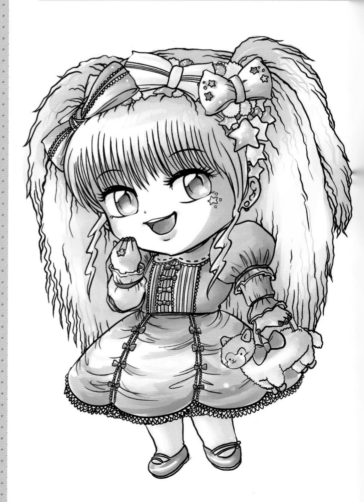

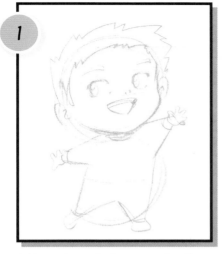

1. Draw two circles—one for the head and one for the body. Then add soft triangular shapes for the two arms and legs, adding small hands and feet to the tips of each.

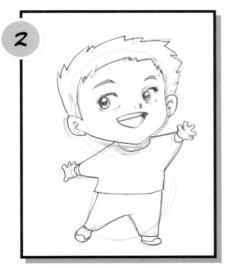

2. Fill in the facial features as you would on a regular manga-style head, but exaggerate the size of the eyes even more and decrease the size of the nose. Add simple details to the body.

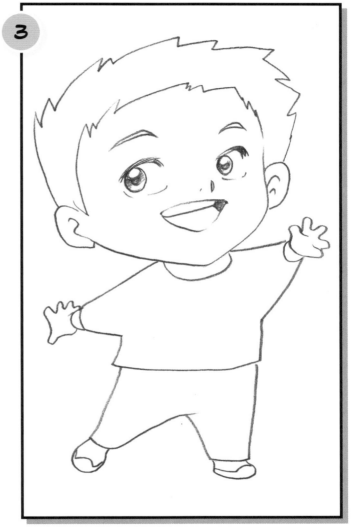

3. Increasingly add more detail to define the chibi—fingers, eyes, clothing, and so on.

Practice here

TRY CONVERTING SOME
OF YOUR CHARACTERS
INTO CHIBIS.

BODY TYPES

Drawing your character in silhouette is a really good way to see if your cast is visually diverse enough at first glance. This will make it easier for the reader to remember your characters, especially if you have a large cast. Consider height, weight, muscle tone, hairstyle shape, clothing, and so on. You could also establish specific characteristic poses for each person.

CONSIDER HOW YOU WOULD DRAW YOUR CHARACTERS IN A GROUP SHOT. THINK ABOUT THEIR DIFFERENT SILHOUETTES AND HOW THEY WOULD BEST BE COMPOSED AS A GROUP.

YOU COULD INCLUDE:
- A TALL CHARACTER
- AN OVERWEIGHT CHARACTER
- A CHILD CHARACTER
- A WISE MENTOR
- A MASCOT

THINK ABOUT THE CAST OF YOUR FAVORITE FILM OR TV SHOW AND THE DIFFERENT HEIGHT DIFFERENCES AND BODY TYPES THEY HAVE. HOW WOULD YOU DEFINE EACH CHARACTER BY SILHOUETTE ALONE?

CLOTHING

Clothing and accessories are important visual tools that will help you give your reader information about your character without you having to spell it out in dialogue. Think about tiny details that could bring out your character's personality: safety pins for punks, waistcoats and pocket watches for elderly academics, heart-shaped buttons for happy characters, diamond cuff links for wealthy people, and so on.

Heavier materials such as velvet should be drawn using straighter lines (although not entirely straight!) and curves. Lighter materials such as thin cottons, puff sleeves, and tulle skirts can be drawn with bubble and cloud shapes. A quick way to draw ruffles and soft draped materials is to draw the baseline first, then draw swooping lines toward the seams (such as cuffs).

Practice rendering textures to add emphasis and detail to clothing. Take a look at the "Shading" section on page 128 for ideas on how to render different textures.

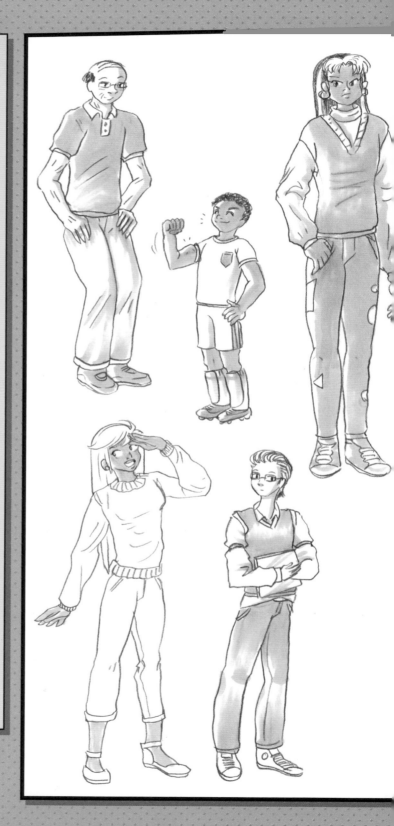

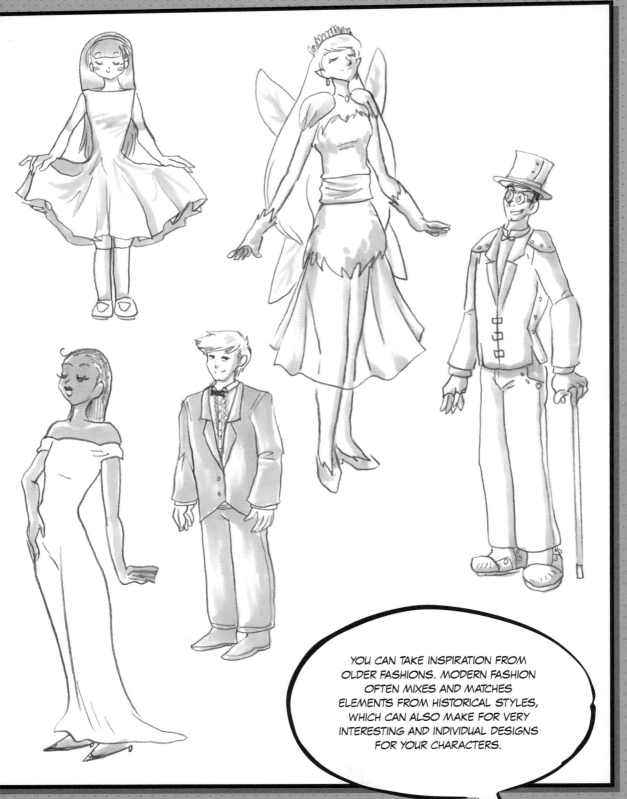

YOU CAN TAKE INSPIRATION FROM OLDER FASHIONS. MODERN FASHION OFTEN MIXES AND MATCHES ELEMENTS FROM HISTORICAL STYLES, WHICH CAN ALSO MAKE FOR VERY INTERESTING AND INDIVIDUAL DESIGNS FOR YOUR CHARACTERS.

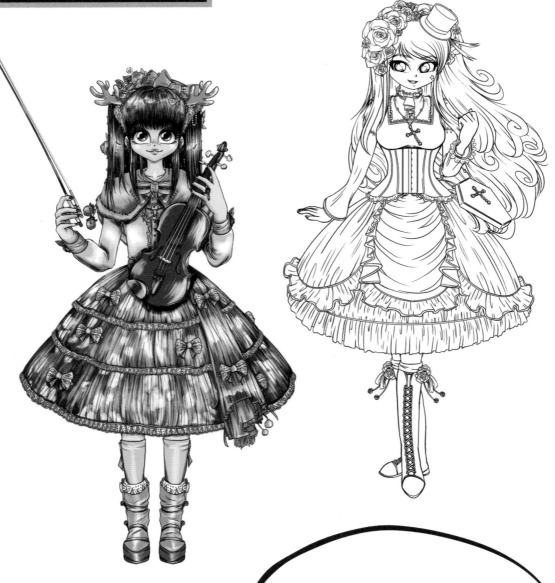

FOR ACCESSORIES SEE PAGE 62

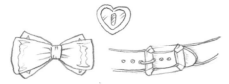

START WITH A SIMPLE PATTERN AND DON'T GET TOO BOGGED DOWN IN DETAIL. DON'T WORRY ABOUT HAVING TO PENCIL IN EVERY DETAIL IF YOU WILL BE PROCESSING THE ARTWORK IN INKS LATER ON; YOU CAN DRAW A PATH IN PENCIL AS A GUIDE AND THEN FILL IN DETAIL USING FINELINERS.

SHOES

Shoes are usually not overly embellished in manga, but it can be fun to add stylistic elements such as bows or pom-poms for cute characters, buckles for pirates, and spikes and studs for gothic types. You can also experiment with various types of shoe and boot heels.

The most common construction for a shoe features a toecap, sole, laces or straps, and sometimes a heel cap. Adding these elements will make the shoe instantly recognizable and provides more detail than simply drawing a shoe-shaped blob. You can add more details—such as logos, charms, or patterns—as you become more confident in drawing your character's specific style of footwear.

TIPS FOR DRAWING FOOTWEAR

- **Socks**—Details might include heel and toe seams, with lines to denote ridges, especially on sports socks.

- **Trainers and flat work shoes**—The sole of the foot should be flat, and the outside of the shoe should mimic the foot shape.

- **Low heels**—Draw the ankle and heel area a little higher up than usual, then add the heel underneath, and draw the shoe design over the foot.

- **High heels**—With high heels, the foot will be raised to look as though the character is on tiptoes.

- **Sandals**—Draw the foot shape flat on the ground, and draw lines around the foot where the straps will sit. The sandal will also need a thin sole, attaching the straps together.

- **Boots**—Use the same technique as drawing flats or heels, but increase the height of the shoe up past the ankle, following the leg's shape.

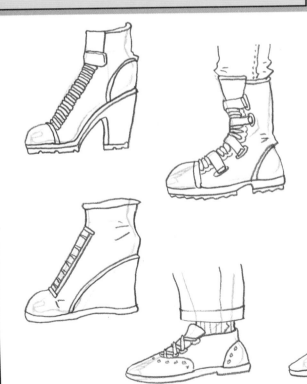

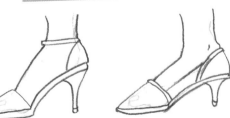

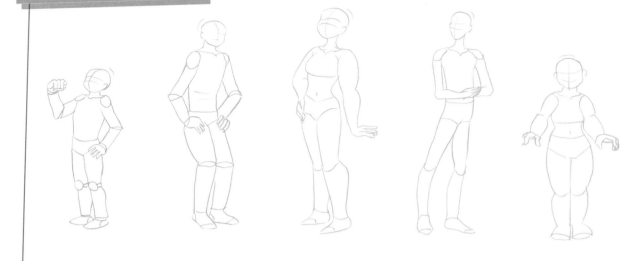

TAKE A FAVORITE CHARACTER THAT YOU'VE CREATED AND THINK ABOUT WHAT YOU COULD DESIGN FOR THEM TO WEAR. ALSO, CONSIDER WHAT EVENTS AND OCCASIONS THEY MIGHT ATTEND THAT THEY MAY NEED DIFFERENT OUTFITS FOR.

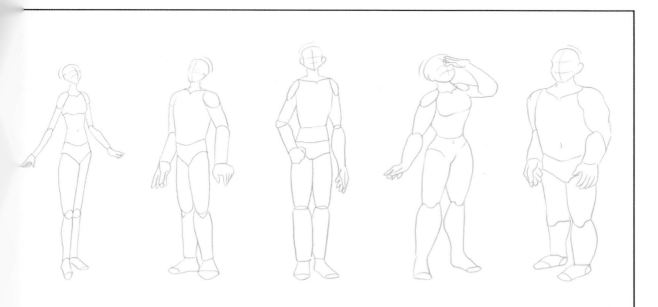

ACCESSORIES

When designing accessories, your character's personality and mood will determine what they wear, as will the time period your story is set in.

When it comes to jewelry, small piercings and gems will only be visible in close-ups. Take a look at diamond facets and the different styles of gem cuts for reference on how to draw these in detail. Geometric shapes can be used to depict precious stones, as well as acrylic costume jewelry.

Other design features of contemporary jewelry include: fabrics, straps, buckles, chains, and clasps. Drawing chains can be initially frustrating, but once you realize it is a repetition of only two shapes (two interlocking chain links), the process can be very relaxing.

THINK ABOUT REPEATING CERTAIN SYMBOLS OR SHAPES IN SMALL WAYS ACROSS YOUR CHARACTER'S DIFFERENT OUTFITS. FOR EXAMPLE, YOU COULD USE A DIAMOND SYMBOL FOR A FEMALE MOVIE STAR. SHE MAY WEAR SUNGLASSES WITH A DIAMOND ON THE STEM, THEN FOR ANOTHER OUTFIT, THE DIAMOND COULD FEATURE IN THE FORM OF A REPEATED PATTERN ON A SKIRT, OR SHE COULD WEAR A DIAMOND NECKLACE.

Try it here

TYPES OF JEWELRY AND ACCESSORIES

1. Earrings (sometimes multiple ear piercings) and ear cuffs

2. Hair accessories—clips, headbands, and hairband jewelry

3. Belts and buckles

4. Bracelets for wrists and ankles

5. Necklaces and chokers

6. Rings for fingers and toes

7. Tiaras and crowns

8. Festival gems and facial/body piercings

9. Chains, zips, and watches

REMEMBER THAT WHEN VIEWING THE REAR PROFILE OF A CHARACTER, THE BUTTERFLY CLASPS OF PIERCED EARS WILL BE ON DISPLAY.

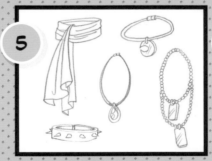

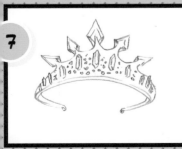

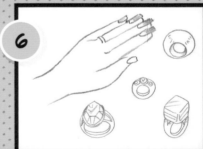

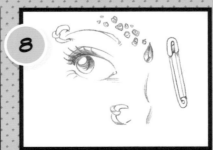

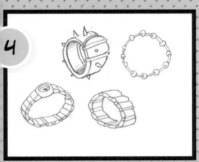

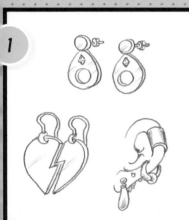

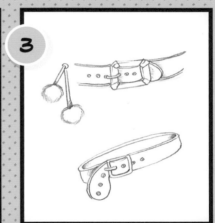

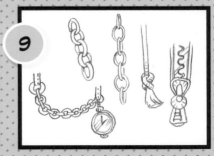

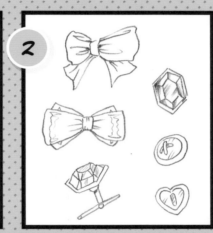

SCHOOL UNIFORMS

Traditional navy-style Japanese school uniforms are popular in manga. Often, Western details are incorporated, such as long ties and blazers, especially for high-school students. Sailor suits are often worn by middle-school students.

Mixing and matching is a great way to develop unique designs for different characters' schools. Each school will often have a summer and winter version, which can involve adding longer sleeves and extra layers.

Think about your old uniform, if your school had one, or look at the uniforms in other manga series for inspiration—make a note of all the different elements that make up a uniform, and how they fit together. What's the color scheme? What is their logo? Does your character adjust their uniform to fit in or rebel?

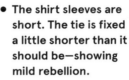

FEMININE SCHOOL UNIFORM

This is Maya, who wants to be a prefect. However, she needs to learn better debate skills, as she gets flustered easily.

Key features:
- Here, swooping lines denote long flowing hair (see page 30).
- The shirt is tucked into the waistband and the skirt is knee-length.
- The shirt sleeves are short. The tie is fixed a little shorter than it should be—showing mild rebellion.
- In winter, this character would wear tights or trousers, with long-sleeved shirts and a sweater or cardigan.

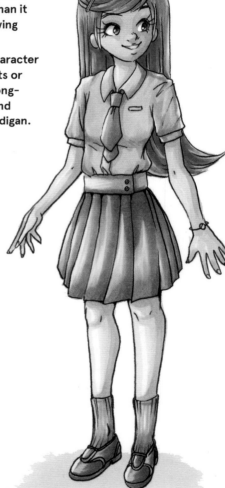

THE JAPANESE SCHOOL UNIFORM IS THOUGHT TO HAVE BEEN INSPIRED BY THE SAILOR SUITS AND SAILOR DRESSES WORN BY CHILDREN OF EUROPEAN ROYAL FAMILIES, AS WELL AS BEING INFLUENCED BY THE IMPERIAL JAPANESE ARMY UNIFORM OF THE TIME.

MASCULINE SCHOOL UNIFORM

Lucas doesn't care about academic subjects, and only has a heart for movies.

Key features:

- The haircut is cropped and a few hairs are out of place. Perhaps this character has just finished playing a sport at lunchtime?

- The shirt is untucked—a teacher will surely point that out sooner or later!

- The short-sleeved sweater is similar to a waistcoat. It will be replaced with a long-sleeved sweater for winter.

- The shoes are formal and paired with long trousers—a bit longer than needed, so the leg bottoms are folded over.

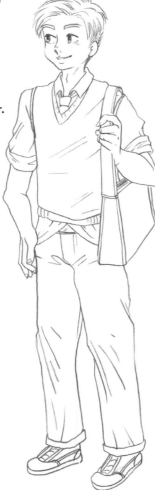

SPORTS UNIFORM

Quinn lives for sports, and he volunteers over the holidays with his older brother. They help to raise funds for new equipment for kids who don't have access to much.

Key features:

- Floppy haircut, gelled back for sports.

- The shirt and shorts are form-fitting without being saggy or too tight, to enable movement without restriction.

- Sports socks textures are denoted with just a few vertical lines.

- In winter, this character could wear a sweat suit.

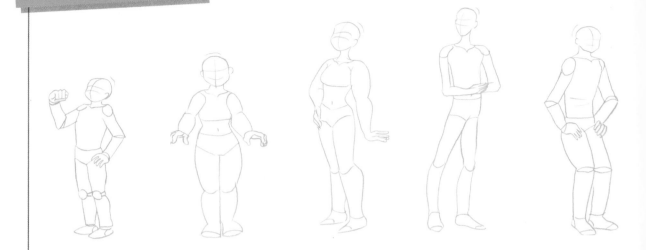

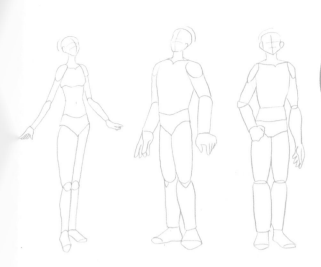

THE MORE PRIM AND PROPER YOUR CHARACTERS' SCHOOL IS, THE CRISPER THE UNIFORM SHOULD BE. IF IT'S MILITARY-BASED, USE A SQUARE, SOLID STRUCTURE FOR YOUR CHARACTERS. THEY WILL WEAR IRONED TROUSERS AND BLAZERS BUTTONED UP TO THE NECK, NAVAL-STYLE SHINY SHOES AND GLEAMING BUTTONS, AND THEY WILL HAVE CROPPED HAIRCUTS.

VILLAINS

Villains can be depicted as the most powerful, glamorous beings that you would never want to cross paths with, or simply as characters with hidden dark sides. With their looks, you can be as extravagant as you want, or infer an evil nature with just one or two subtle hints. Either way, your villains should make your reader—or you, the artist—feel uncomfortable, or even terrified!

REMEMBER NOT TO USE DEFORMITIES OR DISABILITIES AS A VISUAL SHORTCUT TO REPRESENT A VILLAINOUS CHARACTER—THIS PERPETUATES A CRUEL SOCIAL STIGMA, AND IS A LAZY CLICHÉ FROM OLD-FASHIONED CARTOONS.

THE CATNAPPER

The Catnapper plucks cats out of their owners' gardens. She doesn't sell them illegally, but hoards them in her house. Her love of cats is pure, but her obsession is not...

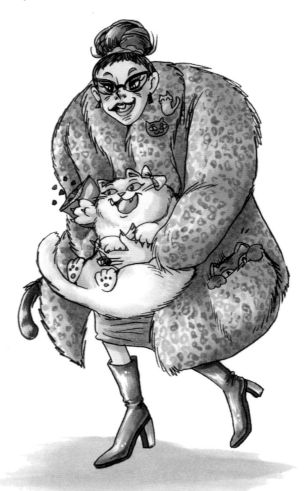

Key features:

- A big fur coat with pockets big enough to hold multiple cats (or one very fat cat), and cat brooches.
- A messy bun and cat-eye glasses.
- Cat treats falling suspiciously out of her pockets.

THE MEGA-CORPORATE BOSS

The boss is an ex-TV host who has inherited lots of family money, which is now stashed in illegal offshore accounts. Too rich to be punished, will he ever be made accountable for the failures of his megacorporation to give back to society?

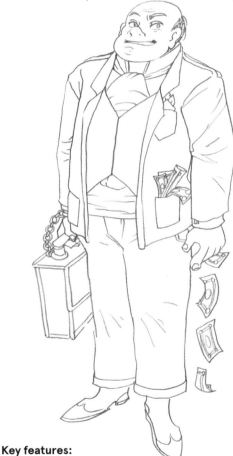

Key features:

- Puffed-up chest.
- Fine, tailored suits and shoes, a huge watch, and money spilling out of his pockets.
- A snooty expression that says he hates being reminded what the minimum living wage is.

THE SCHOOL SNEAK

The Sneak's school uniform is the same as everyone else's, and you never know quite what she's thinking.

Key features:

- Thin and willowy, and constantly shrugging as if to say "So what?"
- A haughty expression, with a protruding lower lip and eyebrows lowered in a sneer.
- Hands stuck in pockets.
- Sloppy socks.

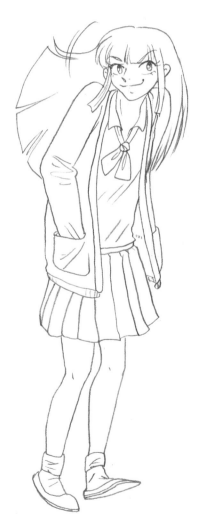

WHAT SORT OF
BACKSTORY DOES YOUR
VILLAIN HAVE? WHAT ARE
THEIR MOTIVATIONS? HOW
CAN YOU PORTRAY THAT
THROUGH THEIR CLOTHING?
WHAT ACCESSORIES DO
THEY WEAR? DO THEY NEED
ANY PROPS?

FANTASY

Otherworldly characters are extremely fun to draw. They can vary from small and delicate fae to larger-than-life brutes. There are many things to consider when creating a fantasy character: Are their hearts good or bad, or are they still learning? How do they interact with the human world? Do they use magic?

When designing fantasy creatures, you can mix and match animal features such as leathery wings, feathers, horns, tails, underbites, and sharp teeth. You can also dress them in historical clothing and accessories such as medieval metalwork, gowns, and shoes with features like straps—avoid anything too modern with this style.

Think about the character's clothing and hairstyle, whether they are part of one race or part of a team from many planets, what language they may speak, what attitude they have, and what their goals are. This background information can tie in with your character's visuals.

ELFIN CHARACTER

This faerie is a specialist in flora knowledge. She believes only in the pure of heart, and knows that those hearts will never grow old.

Key features:

- A gown drawn with curved lines to help denote movement and the lightness of the material.
- Willowy limbs, purple skin, pointed ears, and small horns.
- A graceful stance, holding a prop that is appropriate to the character's personality.

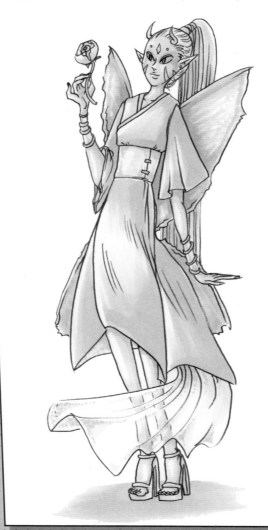

BRUTISH CHARACTER

A legendary ogre with an unusually cool temperament, this character discovered old samurai films and will fight only for honor, though sometimes with sneaky tricks.

FOR ACCESSORIES
SEE PAGE 62

Key features:

- A round-edged, boxy shape with bulky arms to depict the strong body.
- Pointed ears, an underbite with sharp teeth showing, and large, bare feet to show that he is not entirely human.
- Clothing details and accessories that relate to the character's role—in this case the character is a martial artist, so he wears loose trousers and angry punk spikes, and carries some of the weapons he has collected from previous missions.

HYBRID CHARACTER

A character with both animal and human features. To draw a hybrid character, select a picture reference of the animal of your choice, and decide how you want to combine it with a human form. Your character could either be half animal or you could mix and match a range of animal features, as in the example below.

Key features:

- Dragon wings and a scaly tail; hooves and horns.
- Fur covering the body resembling items of human clothing.
- A pan flute held by clawed fingers.

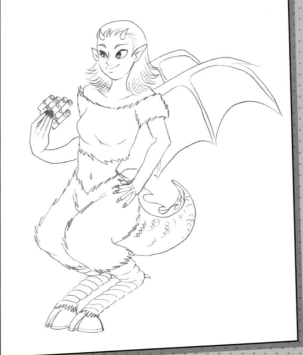

Practice here

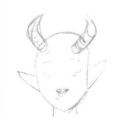
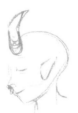
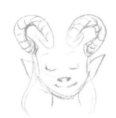
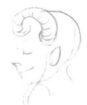

HORNS ARE BEST PLACED
ON THE FOREHEAD OR THE TOP
OF THE HEAD AS SYMMETRICALLY AS
POSSIBLE, AS THEY WOULD BE ON REAL
ANIMALS. DON'T FORGET YOU CAN USE
AN IMAGE SEARCH TO REFERENCE
MOOSE, GOATS, RHINOS, NARWHALS,
AND SO ON FOR IDEAS.

MARTIAL ARTS

Martial arts have always been a popular theme in manga, likely because of their accessibility and energy that transcends all cultural boundaries, and also possibly because of their ancient Asian origins.

There are plenty of manga series that you can refer to for inspiration in this area. Channeling the dynamism of martial arts into your comics can only be a good thing—it's exciting to draw and an energetic read!

YOUR CHARACTER'S PERSONALITY AND TRAITS WILL IMPACT ON THEIR FIGHTING STYLE. TAKE THESE FACTORS INTO CONSIDERATION WHEN THINKING ABOUT WHAT SHAPES TO START WITH.

TRADITIONAL KENDO ARTIST

Kendo is a Japanese form of fencing that uses bamboo swords and protective armor, and is widely practiced in Japan. This character believes wholeheartedly in the ways of kendo, so wears only the traditional kendo outfit—even to the shops—and is often mocked for it.

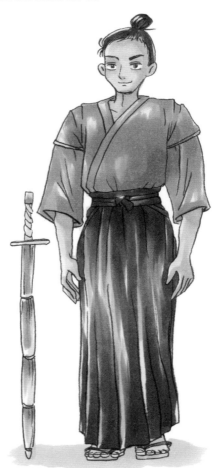

Key features:
- A straight stance with a body that is almost rectangular.
- Kendo robes with straight, crisp pleats, and a waist tie with a firm grip.
- A kendo sword by his side, hair pulled back into a no-nonsense bun, and wearing traditional footwear—bare feet in tatami sandals.

SUPERPOWERED TEENAGE ALIEN

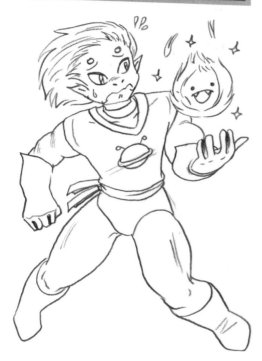

Our protagonist has just arrived on Earth, and only wants to make friends but, unused to Earth's gravity, is finding it very hard to control his clumsy powers!

Key features:

- Body structure underpinned with triangular, jagged shapes. An awkward stance and sweat drops portray embarrassment, clumsiness, and hyper energy.
- Spiked hair—a common trait of manga protagonists—that conveys energy and action.
- Stretchy martial arts clothes for ease of movement, with a space logo to emphasize that he is not from this planet.

KARATE COMPETITOR

Karate is a martial art that originated in Asia. It can be practiced as an art form, as self-defense, or as a combat sport. It requires creativity, self-discipline, and hard training.

In love with pop culture and martial arts in equal measure, this character can't decide whether to concentrate on dance or karate, so is taking classes in both.

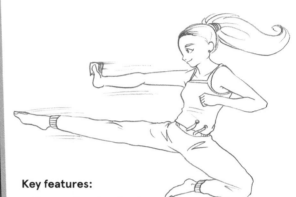

Key features:

- Focused and poised body, with bendy but firm limbs.
- Comfortable gym wear, with nothing that might tangle, and only sweatbands for accessories.
- A practical ponytail keeps her hair out of her face.

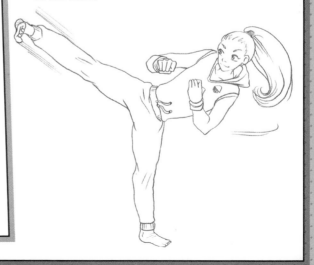

Practice here

LOOK ONLINE FOR IMAGES OF POSES, OR PAUSE VIDEOS OF MARTIAL ARTS. IF YOU KNOW PEOPLE WHO STUDY MARTIAL ARTS, SEE IF YOU CAN SIT AND OBSERVE THEM IN A CLASS FOR YOUR DRAWINGS.

PROPS

Once you've created your characters, you can begin to play around with props for them to interact with and carry. These items should be in proportion to your character, and need to be consistent in each panel, so bear that in mind.

Think about how props could add to a scene. Will you need to render them fully, or can you just hint at them? Are they imperative to your character? For example, your photographer will definitely need a camera!

THE MORE DETAILED AN OBJECT IS IN A SCENE, THE MORE DETAILED IT WILL HAVE TO BE IN OTHER PANELS THROUGHOUT THE WHOLE COMIC. ALWAYS AIM FOR CONSISTENCY.

TIPS FOR DRAWING PROPS

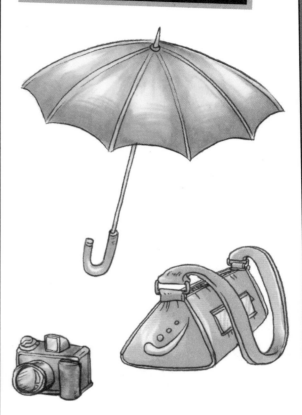

- Items that are boxy will always have parallel lines.

- To draw items like umbrellas, always start with a basic "T" shape.

- Don't be afraid to use references for detail.

- The amount of detail you give to props will depend on the complexity of your character design and other items in your manga pages. For example, whether you draw a simplistic camera or a more realistic one will depend on how realistically you have drawn their bag.

EVERYDAY PROPS

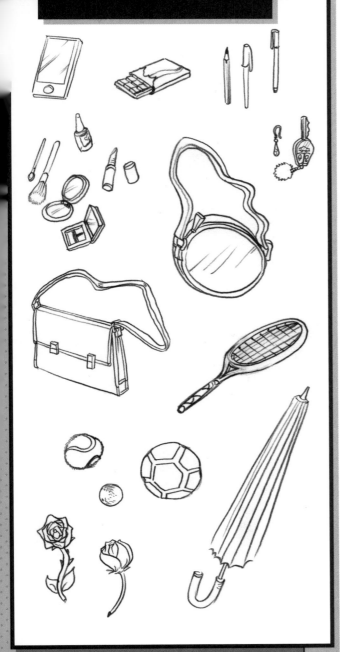

GESTURES AND GRIPS

Think about the gestures required for the character to interact with different props:

- Hands holding a small object (TV remote control, brush, camera).
- Hands holding thin rods (umbrella, toothbrush, cane).
- Hands holding straps (dog leash, handbag).
- Hands typing on keyboards or phones.
- Fingers holding small objects (coins, papers, earrings).

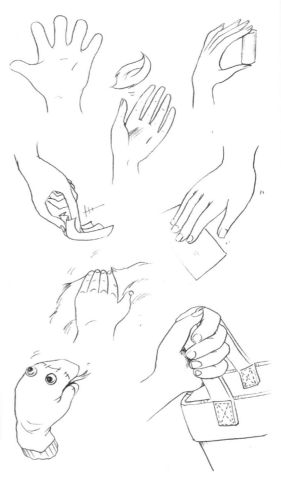

ANIMALS

You can use the circle/oval method discussed earlier in the book to establish the basic shapes of your animals. Think about the animal's size and style in relation to any human characters they will be appearing alongside.

For kawaii (cute) animals, the eyes and noses should be cartoonish. Use circle shapes to denote the whites of the eyes, and round, dark iris/pupil shapes to denote almost humanlike expressions. Some animals, like cats, have vertical irises which can give them an aloof expression, whereas if a cat is drawn with large, rounder irises, it can make them cuter in cartoon form. Similarly, give the animals humanlike mouth shapes, making them look as though they are smiling.

Alternatively, if the animal is to appear alongside characters with adult proportions, or in a manga with a more complex series style, you might wish to draw more realistic representations. Adding detail and texture will give your animals a more mature look, as will using longer shapes, muscular limbs, and more realistic eyes and other facial features.

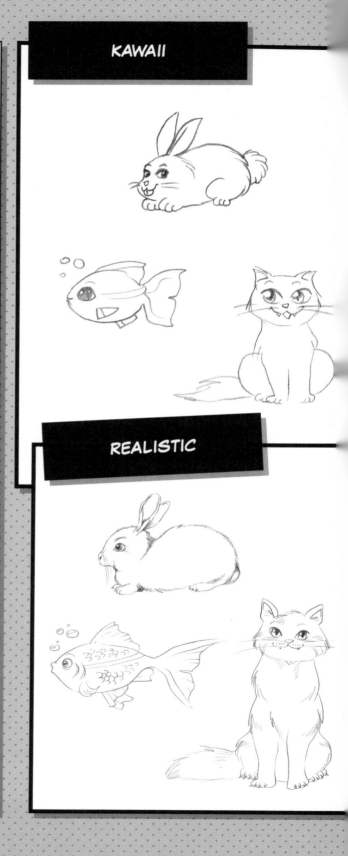

KAWAII

REALISTIC

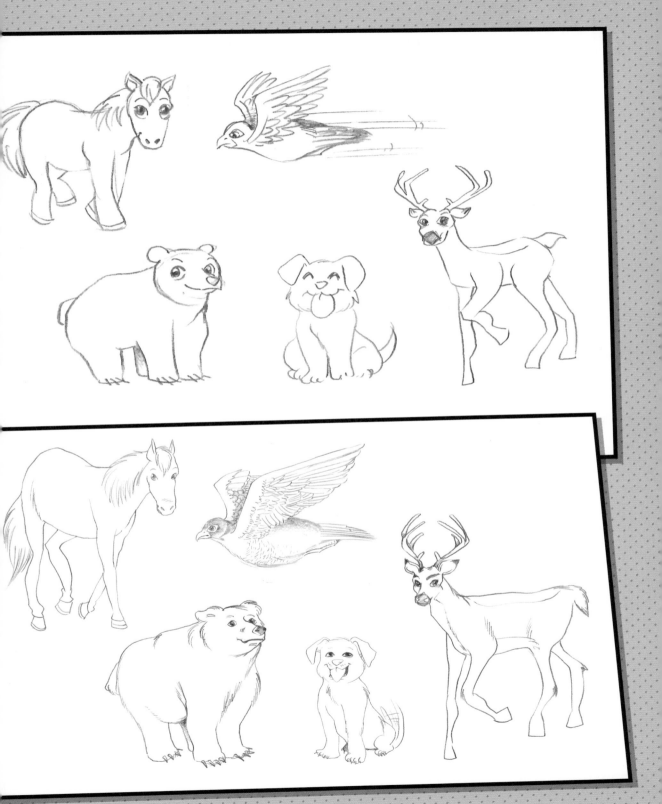

ANIMALS HAVE CHUNKIER PROPORTIONS THAN HUMANS, AND THEIR KNEES BEND DIFFERENTLY THAN OURS.

REMEMBER THAT YOU DO NOT
HAVE TO DRAW EVERY FEATHER
OR SCALE—JUST A FEW IN
PATCHES AROUND THE BODY
WILL SUFFICE.

SET THE SCENE

POSES

You have now started to create characters and think about their personality and style. This section covers classic manga poses. We have already touched on how a character's personality might affect their stance; here we will look more in-depth at the poses required for different social situations, movements, and character interactions.

A good way to create convincing character poses is to draw from observation. Get a friend or family member to pose for you, or attend a life drawing class to get inspiration, as this will help you capture the subtle gestures in static poses.

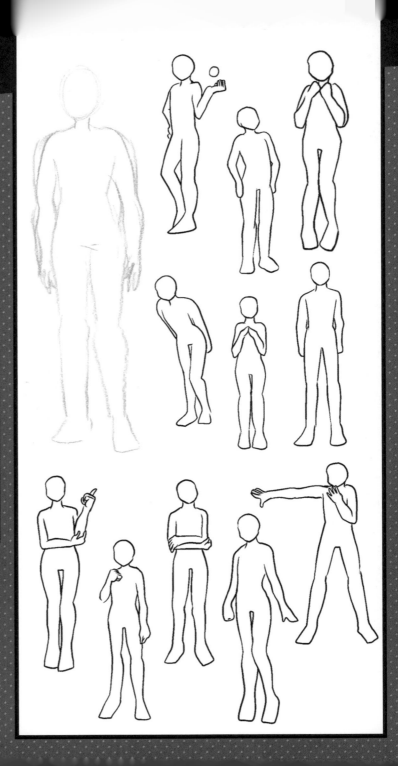

STANCE & MOTION

Poses in manga can be underpinned by the use of lines: stance lines (shown in red) can help construct the pose of your character, while motion lines (shown in blue) can be used to emphasize movement in the final drawing.

The initial stance line should be drawn quickly, then circles can be added in pencil to get the correct proportions for the head and body. You can then add ovals and further circles to shape the limbs.

Motion lines can describe small movements (with a few short, curved lines) or large movements (with long, swooping lines).

Over the next few pages are some poses that you will see frequently in manga.

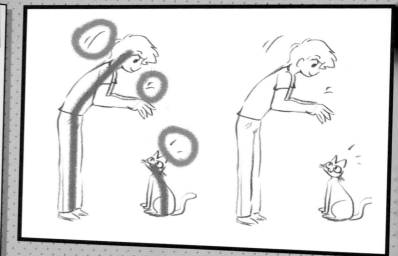

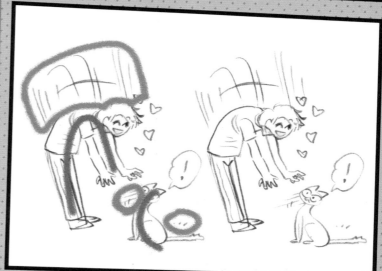

"MOTION LINES" IN MANGA CAN ALSO REFER TO SPEED LINES OR ACTION LINES, WHICH EMPHASIZE MOVEMENT.

HAPPY

This character has received a nice letter. He is leaning back slightly, happily surprised by the letter's contents. Small motion lines near the face show that he is beaming.

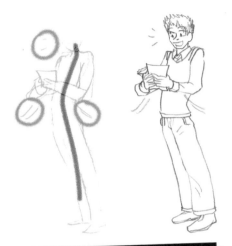

GRUMPY

This character is having a frustrating phone call. Small lines have been added between his eyebrows to show that he is irritated. Motion lines are used to highlight the character's slumped posture.

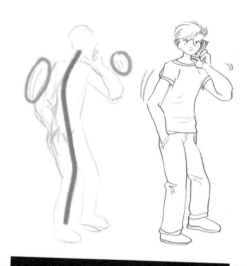

WORRIED

This character has received worrying news. He is gripping the piece of paper and leaning forward to read it. His worried expression is emphasized with small sweat drops jumping out from the head.

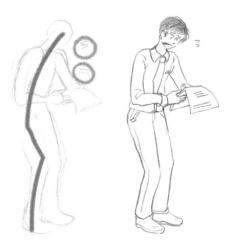

ANGRY

Here is a character who is ready for a fight. The stance and motion lines show how he is poised, but not yet moving forward.

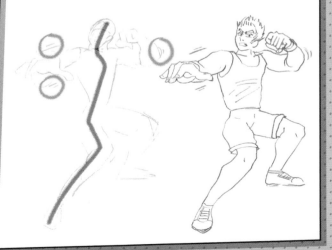

WALK CYCLES

When we walk, there is a typical sequence of movements that we follow. Here is a diagram outlining the motions, with small arrows explaining the directions of the limbs. The faster the character is moving, the more exaggerated their motion lines should be.

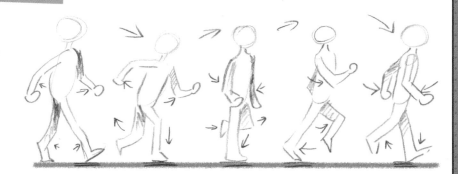

WALKING

Here is a character walking leisurely. The stance line is a fairly smooth S-curve. If your character is whistling or listening to music with earphones, you can add a musical note beside their head.

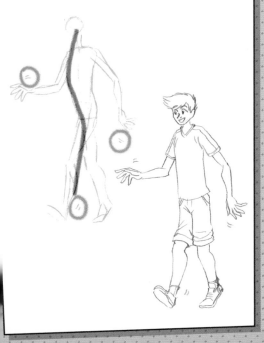

STROLLING

This character is walking her puppy. The puppy is so excited, its front paws aren't even touching the ground. Its tail is wagging energetically; the illustration shows the tail as both up and down in the same frame, with motion lines to emphasize the movement. This is a visual shortcut for depicting fast motion that can be replicated in a lot of other scenarios as well. The owner is walking with wide steps, with her arm out to help her balance. There are motion lines by her mouth to show that she is beaming.

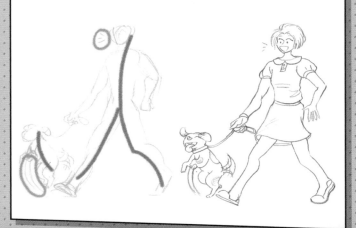

FOR MORE EXAGGERATED MOTIONS, YOU WILL NEED TO USE THE SAME TECHNIQUES DISCUSSED ON THE PREVIOUS PAGES, BUT WITH MORE MOTION LINES TO DELIVER HIGHER LEVELS OF SPEED AND ENERGY.

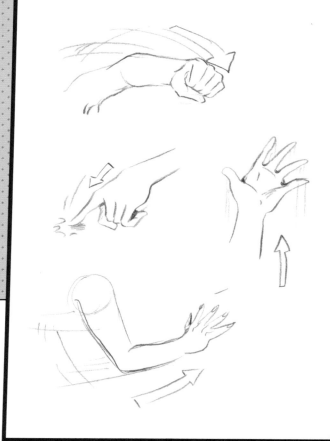

RUNNING

Here is a character running for the bus. He is running so fast that his feet don't touch the ground. This is comical because this is not a realistic way of running, but visually gets the idea across. Motion lines highlight the direction of movements.

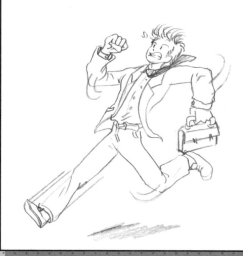

FIGHTING

Here is a fighting character in motion. The stance line shows the strength behind his kick. His right foot is planted on the ground, his body is upright, and motion lines surround the kicking foot.

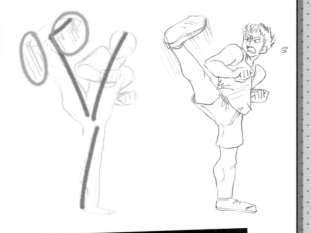

DANCING

Here is a confident character dancing, and her favorite song has just started. The stance line shows that she has her arms in the air and is arching backward. Motion lines are used to show that she has raised her arms and kicked her leg backward in excitement.

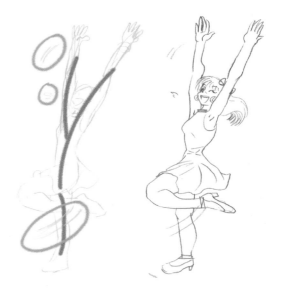

TRUDGING

This sad character is trudging home in the rain. The stance line shows she is hunched and looking down. Her arms are crossed and her hair hangs in straight, dripping strands. Wiggly motion lines are used to show that she is shivering.

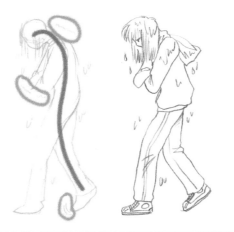

Here is a less confident character on the dance floor. The stance line here shows his stiffness and awkwardness. Motion lines depict the movement of dancing within a static frame, with sweat drops to signify how nervous he is.

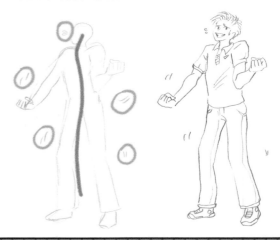

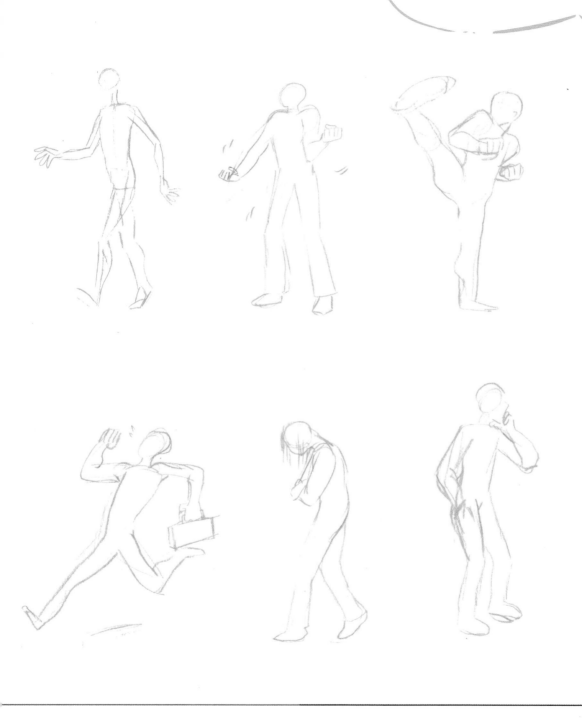

DRAW CLOTHES OVER THESE CHARACTERS, CONSIDERING HOW THE MATERIALS WILL CREASE WHEN THE CHARACTER MOVES.

INTERACTIONS

To draw interactions between characters, you use the same techniques that you would use to show a single character in a pose or in motion, but you will need to think about how they will be affected by other characters in the scene.

Think about your characters' relationships. How well do they know each other? Also consider each character's personality. Are they a hugger? Shy? Moody? Your characters' behavior and gestures toward each other will all be dependent on these factors.

SHAKING HANDS

Here, two characters are meeting for the first time to collaborate professionally. From the stance and motion lines, you can see that the character on the left is very keen, leaning in and beaming, while the other character leans slightly away. The character on the left is also using both hands in greeting. These subtle differences show that the character on the right has more authority in this situation.

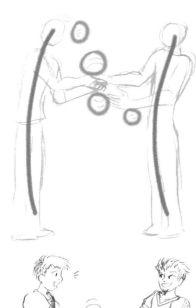

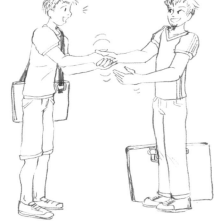

HUGGING

Here are two friends meeting for the first time in a while. The expression of the character whose face we cannot see could be depicted in the following panel, while they are still embracing, which would convey their feelings to the viewer, but not to their friend.

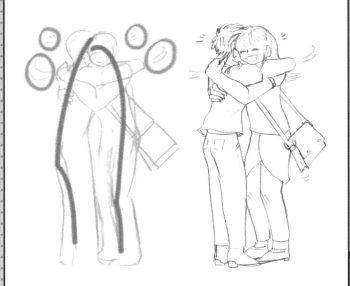

PASSING A BATON

Two different types of gestures are present in this pose—those of delivery versus collection.

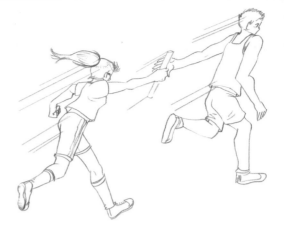

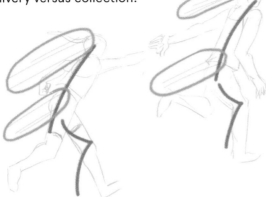

The runner in front has slightly shorter motion lines to show that he is running more slowly than the runner passing the baton.

PICKING UP A CAT

Short, curved motion lines show that the character is bending tentatively toward the cat. The faster the bend, the larger the motion lines would be. Wobbly lines could be added near the forearms to imply fear—perhaps this particular cat bites. The lines by the cat's eye show that it has noticed the approaching interaction.

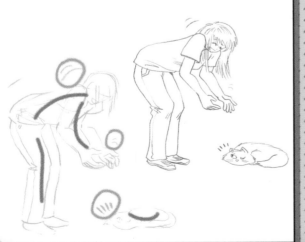

REWARDING A DOG

The stance lines here show that the character is bending down with a soft curve, while the dog is sitting rigidly, eagerly awaiting his treat. Motion lines have been added to show that both characters are beaming and that the dog is wagging its tail.

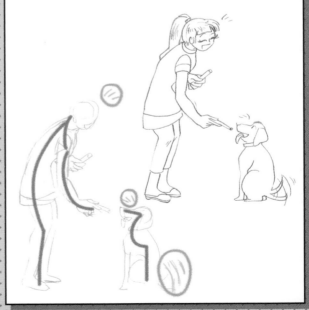

TALKING

When drawing characters talking to each other in social situations, the hardest thing is getting the correct proportions for your characters' heads and bodies. It's important they are in proportion to each other, especially if your characters are supposed to be roughly the same age, height, etc. If one character's head is larger than the other's, the scene can end up looking a bit odd.

To address this problem, assess your proportions early on in the drawing process and adjust if necessary. If you are drawing in a computer program, adjustments can be made at later stages, but it's good practice to spot and assess proportion issues during the early pencil stages.

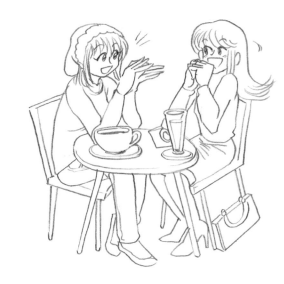

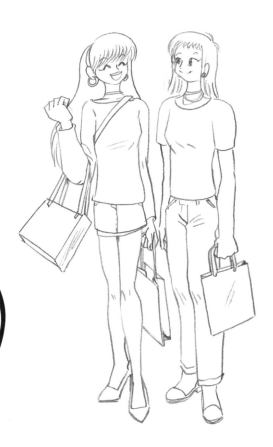

IF YOUR CHARACTERS ARE WALKING AND TALKING, THEN THEIR ATTENTION WILL BE DIRECTED TOWARD EACH OTHER AND THIS WILL BE REFLECTED IN THEIR BODY LANGUAGE. THEY MAY BE LOOKING AT EACH OTHER, ANGLED TOWARD ONE ANOTHER, USING HAND GESTURES, AND SO ON.

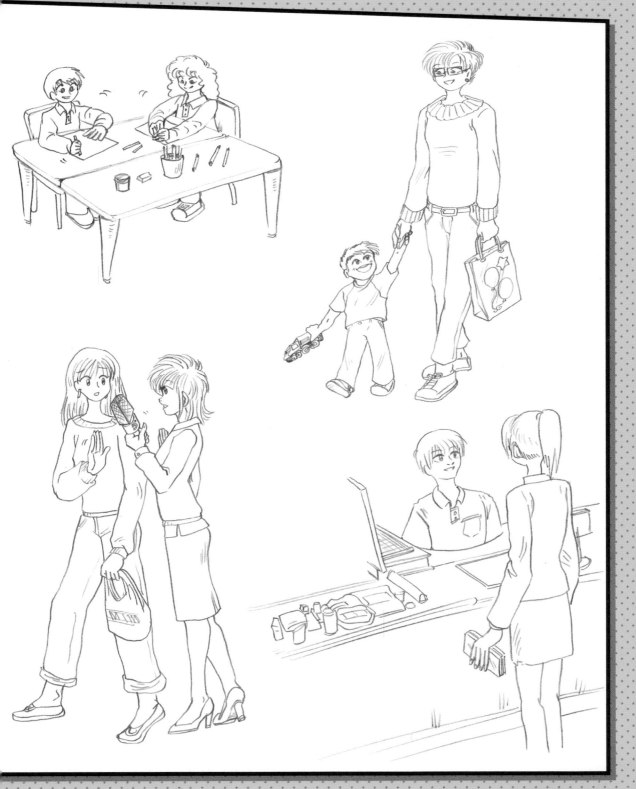

Practice here

COMPOSITION

Composition is the way a scene, a page, or a panel is set up. "Cinematic composition" is one of the key features of manga—many panels can be used to depict a very tense or dramatic scene.

Once you have thought about the basics of composition, you will be able to set the tone you want in your comics. Creating manga means you are your own movie director; imagine that your panels are your TV screen, and think about how best to show what your characters see and feel, and how this will impact the reader.

This is also where backgrounds and scenery will help, with the use of zoom-out shots to set the scene, exploring emotions such as loneliness, or simply following your character's journey.

WATCHING MUSIC VIDEOS AND READING A RANGE OF COMICS IS A GREAT WAY TO RESEARCH HOW DIFFERENT CREATIVES DEPICT A RANGE OF EMOTIONS AND ACTIONS.

COMMON WAYS TO COMPOSE YOUR PANELS

1. **The three-quarter view**—The most common panel shot for a character, this is probably the best way to introduce a character to the reader.

2. **Profile/side-on shots**—Useful when your character is talking to another character, or delivering a monologue.

3. **Isometric angles**—Used when depicting a character walking down a street or staircase.

4. **Angles from underneath**—These are hard to draw without making your character look too goofy. Only use when the focus in the panel is on something happening overhead, and your character is looking upward at the action above.

5. **Top-down (bird's-eye) view**—If something's happening underfoot, or if a character is looking downward from a balcony, a top-down shot is useful.

6. **Fish-eye lens**—Useful if you are drawing your characters in a music video or advertisement, this lens style is used in real-life media, so why not put a shot in your comics?

7. **Close-ups**—Good for intense, dramatic expressions and emotions; add extra touches such as wrinkles, frown lines, and eye details within the pupil. Adding shade and shadow helps convey some more intensity if required, or you can emphasize softer emotions with heart graphics, bubble patterns, and so on, surrounding the character. Good for intense emotions. (See page 128 for more on shading.)

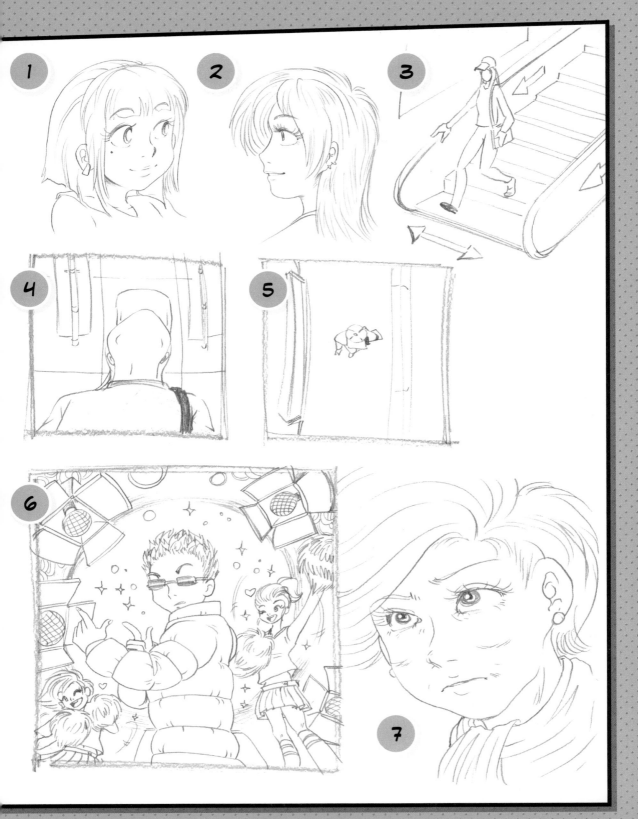

IF A CHARACTER ACKNOWLEDGES
THE READER, THIS IS CALLED "BREAKING
THE FOURTH WALL," WHICH CAN LEAD TO
A MORE INTIMATE, SOMETIMES COMICAL
EXPERIENCE FOR THE READER, WHO WILL NOW
BE GIVEN KNOWLEDGE ABOUT A FEELING OR
SITUATION WITHOUT THE REST OF THE CAST
WITHIN THE STORY KNOWING ABOUT IT. THIS
HAPPENS IN COMICS SUCH AS **DEADPOOL**
AND **SQUIRREL GIRL**.

YOUR COMIC PAGES DO NOT HAVE TO BE SET IN STONE EARLY ON. IT'S A GOOD IDEA TO CREATE A PLAN FOR YOUR PANELS USING STICKY NOTES. THIS WAY YOU CAN ADJUST THE FLOW OF YOUR COMIC EASILY BY MOVING PANELS AROUND, OR REMOVING PANELS TO SEE IF SOMETHING LOOKS BETTER.

PERSPECTIVE

Here are some ideas for how to compose panels using different shot perspectives. Arrows have been added so you can see that, even though construction of a scene can look complicated, really there are only two directions for isometric scenes, or three directions for three-dimensional scenes with vanishing points, to concentrate on. The "vanishing point" is when the perspective view disappears into the distance.

Draw arrows from the outside of the panel toward the vanishing point (marked X), in the center of the image, or the point farthest from the viewer. Adding lines helps to construct the scene, from the buildings close to the viewer to buildings farthest away.

FRONT VIEW

This straight-on shot shows a character in front of a building, waiting to meet someone. This is constructed mainly using horizontal and vertical lines.

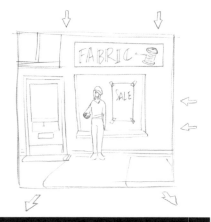

SIDE VIEW

This side-on shot shows a character opening a door, and entering a shop. This is constructed mainly using vertical lines and angled lines that are directed into the distance. The vanishing point is somewhere behind the door.

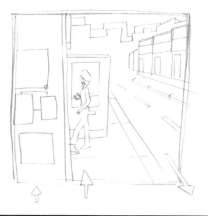

2D ISOMETRIC VIEWPOINT

The scene is constructed using horizontal lines and diagonal, parallel lines. This viewpoint is suitable for CCTV frames, or if a character is watching from a window.

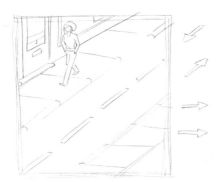

3D VIEWPOINT

This shot uses a central vanishing point that all lines point toward. This gives the shot a sense of depth, and is often paired with "inner monologue" thought bubbles.

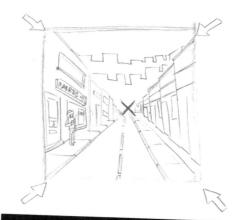

TOP-DOWN VIEWPOINT

Here, the character is seen directly from above. This shot is a direct, top-down view known as a "bird's-eye view." Only the top of the head, the shoulders, and feet are visible from this angle. No facial features can be seen, or any clothing details other than perhaps the top of a hat.

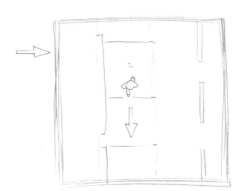

FISH-EYE LENS VIEW

This view is also constructed with lines pointing toward a vanishing point, but here the lines are distorted. The horizontal lines bend toward the center and the vertical lines become almost circular. This view would be perfect for a character posing for photos, or even being spied on.

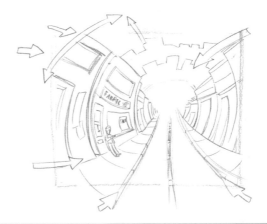

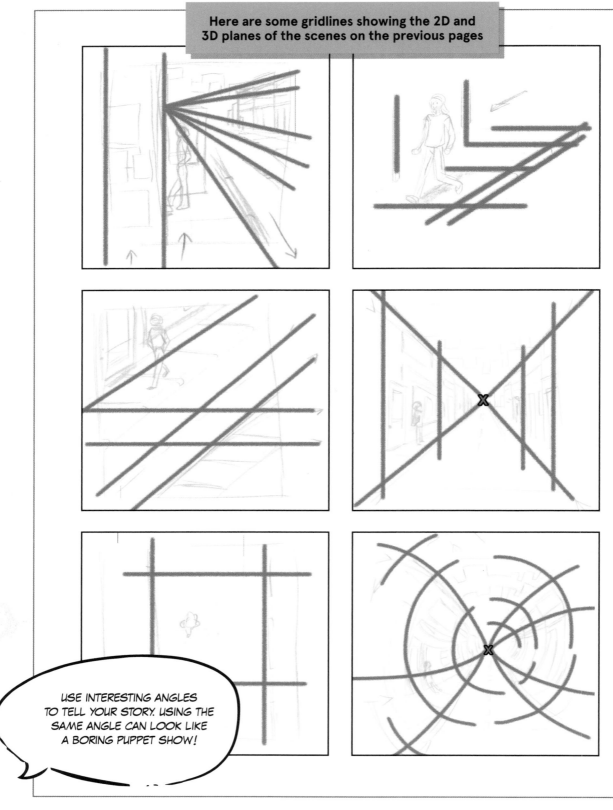

Here are some gridlines showing the 2D and 3D planes of the scenes on the previous pages

USE INTERESTING ANGLES TO TELL YOUR STORY. USING THE SAME ANGLE CAN LOOK LIKE A BORING PUPPET SHOW!

HOMES & NEIGHBORHOODS

Before you start drawing your characters' surroundings, think about their life some more. Which country do they live in? Do they live in a city or the country? Are they surrounded by greenery or buildings?

When it comes to your characters' homes, their living situation will reflect their circumstances and income. Are they living with family or a roommate? Do they live alone or with a partner? They could live in mansions, detached or semi-detached houses, cottages, apartments, or bungalows. Think about other locations too, like where your characters work or go to school, and where they spend their free time.

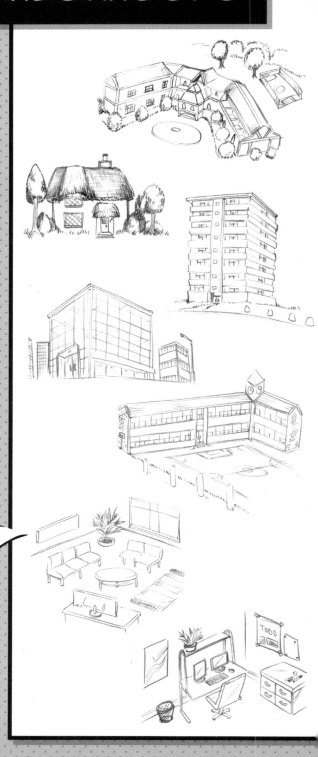

STREET VIEW ON GOOGLE MAPS IS A VERY GOOD TOOL FOR TAKING A LOOK AROUND URBAN ENVIRONMENTS ANYWHERE IN THE WORLD. OTHERWISE, IF YOU HAVE BEEN LUCKY ENOUGH TO TRAVEL ABROAD, SETTING YOUR STORIES IN THE ENVIRONMENTS YOU'VE VISITED WILL ADD AN EXTRA DIMENSION TO YOUR WORK.

NEIGHBORHOOD PANELS

Rulers and triangle rulers are really useful when plotting out architecture; use them to determine your vanishing points and draw straight parallel lines. Some digital drawing programs also have rulers and perspective guides in their toolbar options.

Each window, door, or signpost does not have to be drawn in full; perhaps more detail can be delivered in your establishing shot, then you can just include visual hints in following panels, so the reader knows where your characters are.

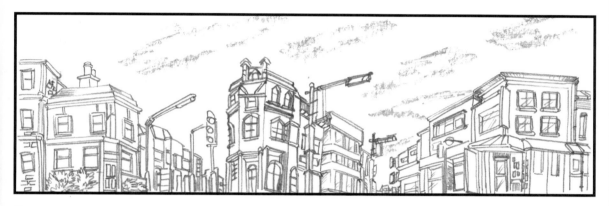

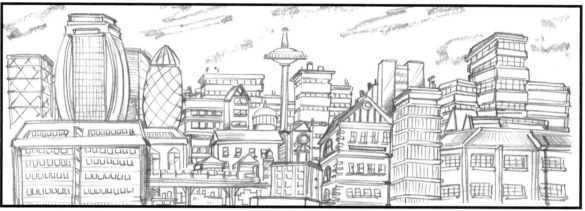

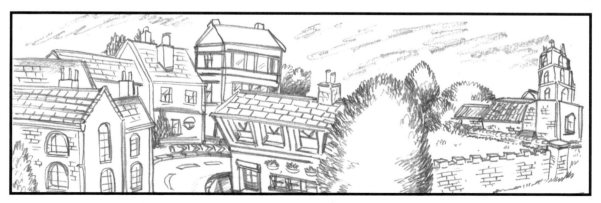

DON'T WORRY ABOUT DRAWING
PERFECTLY STRAIGHT LINES WHEN
INITIALLY SKETCHING OUT STRUCTURES—
YOU CAN USE RULERS WHEN ADDING
YOUR FINAL LINES.

THERE IS NO NEED TO DRAW
EVERY BRICK IN A WALL OR EVERY
DETAIL OF GRAIN IN WOOD. DRAWING
SOME BRICKS, SOME LEAVES, OR
SOME TEXTURES IN GENERAL AREAS
IS ENOUGH FOR THE READER TO GET
THE GIST OF THE TEXTURE.

THE NATURAL WORLD

If your character is based within a more naturalistic setting, as opposed to an urban one, then adding relevant types of greenery will add personality and depth to your backgrounds.

You do not have to draw every leaf on every tree; you can add shadow and a selection of foliage patterns, as depicted here, to convey textures to the reader.

Outdoor scenes won't always be grass and trees for miles—think about whether a mix of brickwork and foliage may be suitable for your scene. Your location may feature man-made items like a play area, or pathways. Perhaps the outdoor setting is for office employees working in a huge city to escape to for an hour at lunch, or your character may just have a fondness for houseplants.

VISIT A PARK, A GARDEN CENTER, OR BOTANICAL GARDENS AND SKETCH THE DIFFERENT TYPES OF PLANTS AND VEGETATION. THIS WILL ENABLE YOU TO DEVELOP YOUR SKILL SET IN DRAWING PLANTS, TREES, AND OTHER TYPES OF NATURAL ELEMENTS THAT YOU CAN USE FOR RURAL ENVIRONMENTS.

SETTING THE SCENE

INDOORS

OUTDOORS

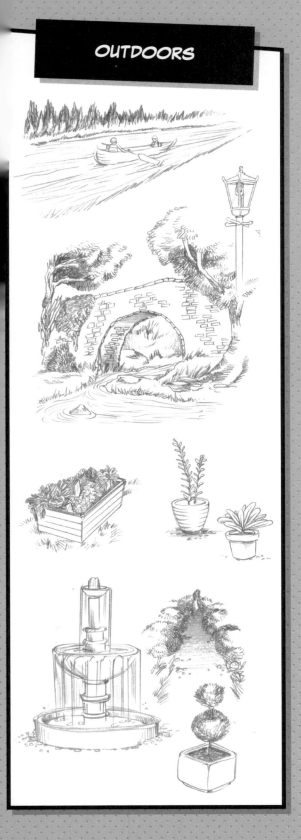

BACKGROUND EFFECTS

Background effects are a good way to emphasize a dramatic panel and expression. Not every panel will require a background object or decoration—emotions and actions are equally good and valid for certain panels.

FLASH LINES ARE USED IN FULL DRAMATIC FORCE ON THIS COMIC PAGE.

SIMPLE PATTERNS

Here are some simple patterns commonly found in manga, all of which can help convey mood, and can support a character's facial expression. Drawing by hand can be quicker and easier than having to locate tone in computer programs, so I'd recommend doing this on paper.

Here are examples of background patterns that have a variety of effects. They can be drawn with brush pens or fineliners. Patterns 3, 4, and 5 will require a ruler lined up against the cross in the center of each frame. Each pattern conveys a different feeling:

1. **Doom circle**—claustrophobic

2. **Horror tendrils**—dread, doom

3. **Flash lines**—an extreme focus on a sudden realization or point of attention

4. **Small bubbles and flash lines**—happiness, excitement, a positive realization

5. **Dots**—whimsical, happy focus, not as drastic as the flash

6. **Gradient shadow**—depression, sinking into a bad mood

DO I NEED A COMPUTER?
NOT AT ALL, AS ARTISTS SINCE THE DAWN OF COMIC-MAKING TIME UP UNTIL THE LATE 1980S DID NOT HAVE HOME COMPUTERS. A COMPUTER AND SOME SOFTWARE ARE GREAT TOOLS, BUT REALLY ALL YOU NEED IS PAPER, A PEN, AND SOME EVERYDAY STATIONERY ITEMS LIKE ERASERS AND RULERS.

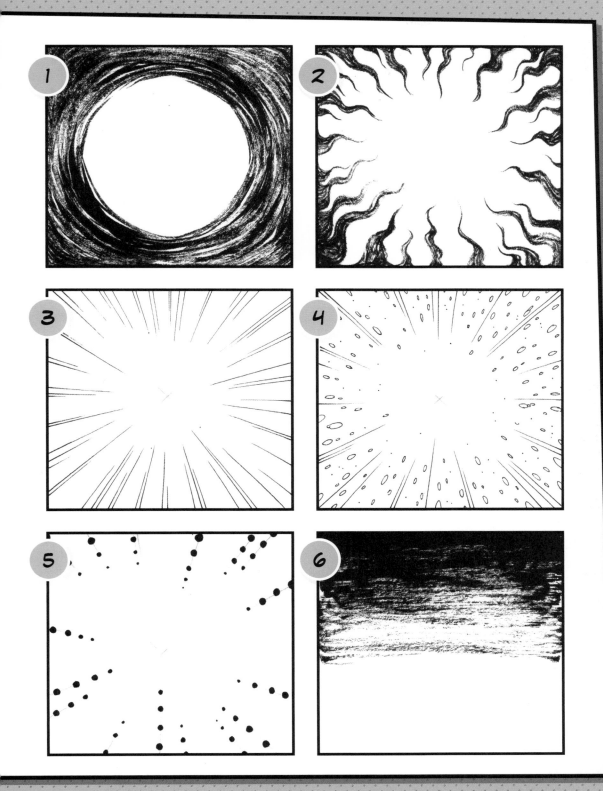

PARTIAL FRAME EFFECTS

These effects don't fill up the whole frame; they just float at the top or bottom of the panel behind the subject of the frame. All these patterns can work in the background behind a character to fill space if there is a lot of back-and-forth dialogue (to avoid having to draw detailed scenery in backgrounds); the square dots are light and fluffy, and the cross-hatching can be used for more intense conversations. The "doom" lines can also imply the feeling of something dreadful being said.

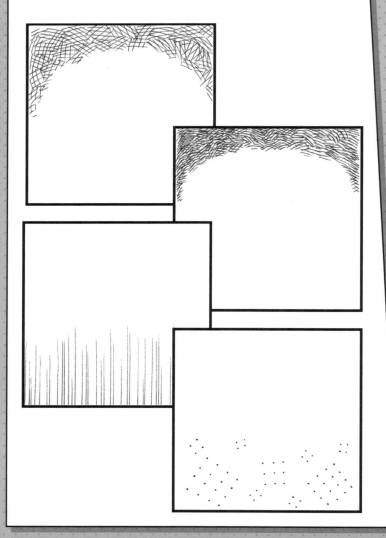

PANEL FLOW

A great way to create drama is to show an emotional buildup over a number of panels. You can vary the speed of the buildup through the number of panels used—for a faster buildup you can merge some panels and expressions together.

Let's have a look at how this works over a three-panel, top-to-bottom structure first. To generalize, the first panel shows the character engaged in an activity; the second panel is a realization; the final panel is the character's reaction.

Summary: Rose is reading a book and is shocked by the reveal.

Panel 1—Rose is reading a book, and nearing the end. She turns the page. Emotion = calm.

Panel 2—She reads a tragic plot twist that she was not expecting. Emotion = shock.

Panel 3—Rose continues to read, but she's upset about the story reveal. Emotion = sadness.

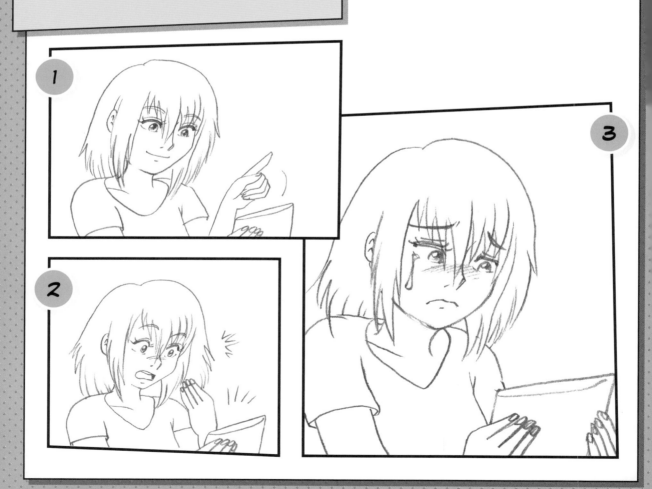

STRIP 2

Summary: Joe is sitting down reading, when someone shouts to warn him that a ball is coming his way...

Panel 1—Joe is taking a break in the park. Emotion = calm.

Panel 2—He realizes someone is shouting to him urgently. Emotion = concern.

Panel 3—Ball incoming! Emotion = horror.

The fourth panel could be the collision, or even just huge text that says "SMACK" to imply the impact without being too graphic!

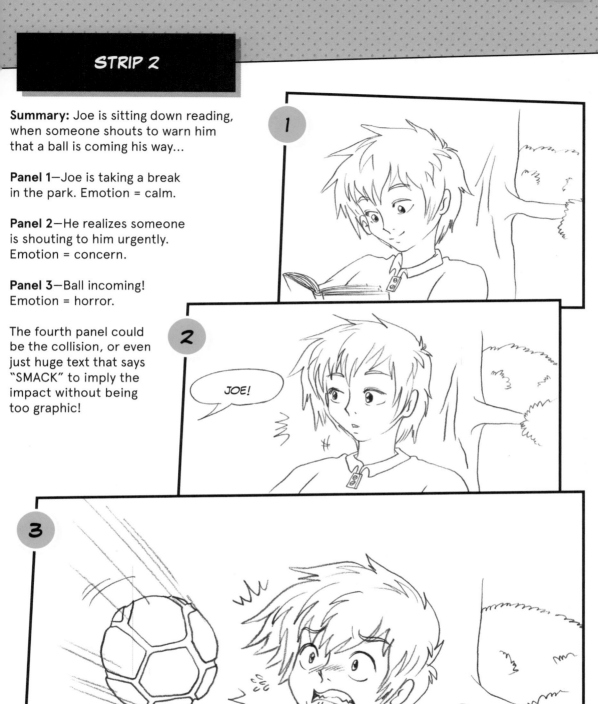

SPEECH BUBBLES & SOUND EFFECTS

TYPES OF WORD BALLOON

If you can, it is best to write down rough dialogue by hand for each panel first. Then you can draw the rest of the panel content around the dialogue bubbles. It is easy to get swept away with drawing characters first, but this can leave little room for speech if not planned out from the start!

The line width of speech balloons should be the same as the width used for the lines of characters' faces; too thick and they will be distracting for the viewer. Try not to leave too much space in between the text and the lines of the bubble, but make sure the text doesn't touch the bubble lines, either.

Brush pens can be useful for special effects lettering, as can fiber-tipped pens.

1. TALKING—THE SPEECH BUBBLE SITS BELOW THEIR HEAD. A TAIL POINTING TO THE SPEAKER'S MOUTH VISUALLY TELLS THE READER WHO IS TALKING. THIS IS PARTICULARLY USEFUL WHEN YOU HAVE A BIG PANEL WITH MULTIPLE CHARACTERS TALKING.

2. EXCLAIMING—THE SPIKED, THICK-LINED BUBBLE CONVEYS VOLUME, PERHAPS ANGER OR A SUDDEN WARNING OR EXCLAMATION.

3. WHISPERING—THE OUTLINE OF THE BUBBLE IS DASHED TO IMPLY THAT NOT ALL SPEECH IS AUDIBLE.

4. WORRIED—THE LINES ARE WOBBLY AND THE TAIL IS WOBBLY TOO, REFLECTING THE NERVOUSNESS OF THE SPEAKER, AND PERHAPS A WAVERING DELIVERY.

5. THINKING—A ROW OF SMALL BUBBLES INSTEAD OF A TAIL SHOW THAT THIS DIALOGUE IS NOT DIRECT SPEECH. THEY POINT TOWARD THE HEAD OF THE CHARACTER WHO IS THINKING.

6. NARRATOR—THE TEXT BOX IS POSITIONED TOWARD THE EDGE OF THE MANGA PANEL. THIS DEVICE CAN ALSO BE USED TO CONVEY CONTEXTUAL INFORMATION (E.G., WHAT DATE OR TIME IT IS).

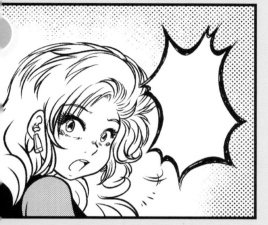

SOUND EFFECTS

Sound effects do not appear in bubbles but are written on top of the artwork.

- Angry and loud sound effects will be written in text that is solid black, heavy, loud, spiked, and angular.

- Quiet, regular, and small sound effects will be filled in with plain white, or a pattern, with a thin pen, and are usually smooth.

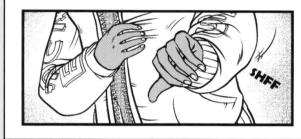

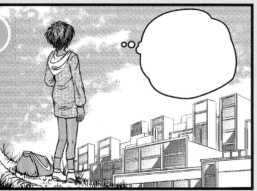

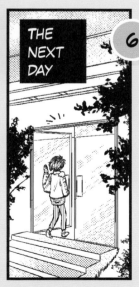

IT'S IMPORTANT TO CHECK YOUR WORK AT THE ACTUAL SIZE IT WILL BE PRINTED TO FIND OUT WHETHER YOUR SPEECH BALLOONS AND TEXT ARE THE RIGHT SIZE AND WEIGHT. IT'S BEST TO DO THIS EARLY ON IN THE PROCESS.

EXPERIMENT WITH DIFFERENT
STYLES OF SPEECH BALLOONS
AND SOUND EFFECTS TO FIND
A SET THAT SUITS THE TONE AND
FEEL OF YOUR COMIC THE BEST.

MAKE SURE YOU DON'T OVERUSE
TEXT IN YOUR MANGA! IS THERE ENOUGH
SPACE FOR ALL OF THE SPEECH BUBBLES?
IF IT LOOKS UNCOMFORTABLE FOR YOUR
CHARACTERS, IT WILL BE UNCOMFORTABLE
FOR YOUR READERS TO LOOK AT.

BE AWARE OF SPACE. EVEN
THE SCRUFFIEST-LOOKING
PROFESSIONAL COMICS
HAVE CAREFULLY DESIGNED
PANEL LAYOUTS.

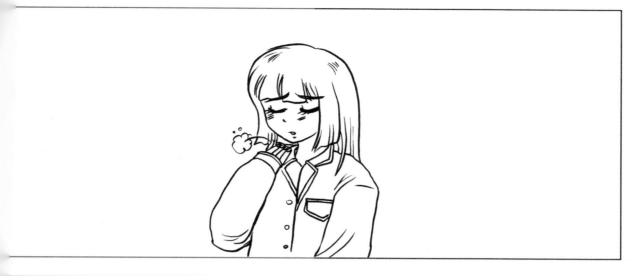

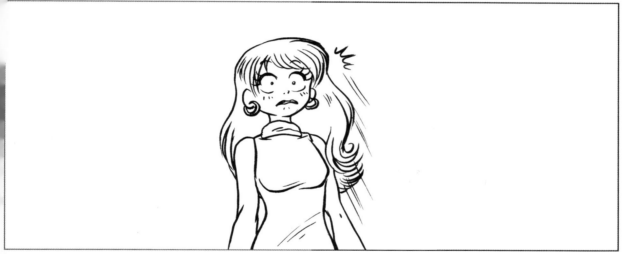

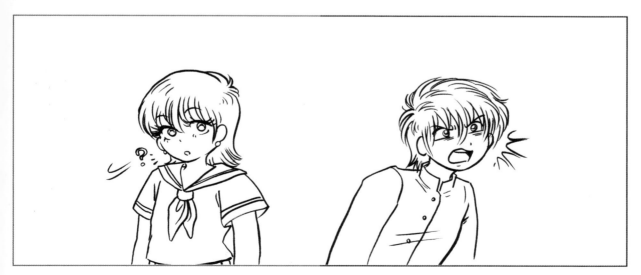

SHADING

Shading is adding a darker area to your artwork, with slight variations of light and dark tones. To shade when depicting texture, you just decrease or increase the density of your mark-making in certain areas. Dramatic shading with a high contrast between light and dark can portray different moods.

TEXTURES

Textures can be depicted in black and white, grayscale, or color, using different methods:

- Pencil grayscale shading
- Pencil color shading
- Monochrome shading—black and white with no mid-tone shades of gray
- Mixing media in color—for example, rough colored pencils with smooth marker pens

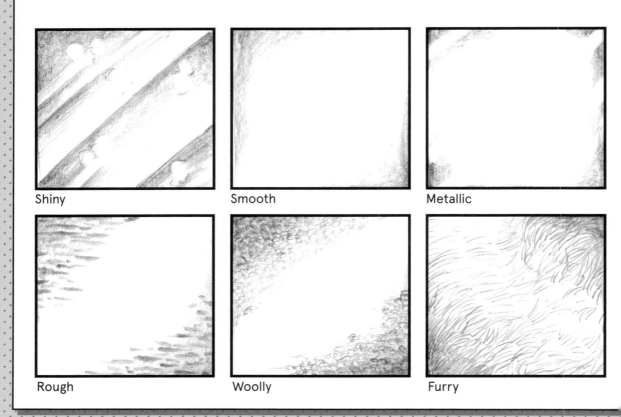

Shiny

Smooth

Metallic

Rough

Woolly

Furry

Light sources in your manga can come from sunshine, lamps, fire, electronics, and so on. Depending on the environment your character lives in, they (or the scene) will be lit by different things.

Here are some examples of how the same image can have radically different moods with different lighting.

1. Overhead lighting

2. Lighting from below

3. Side lighting (from left)

4. Side lighting (from right)

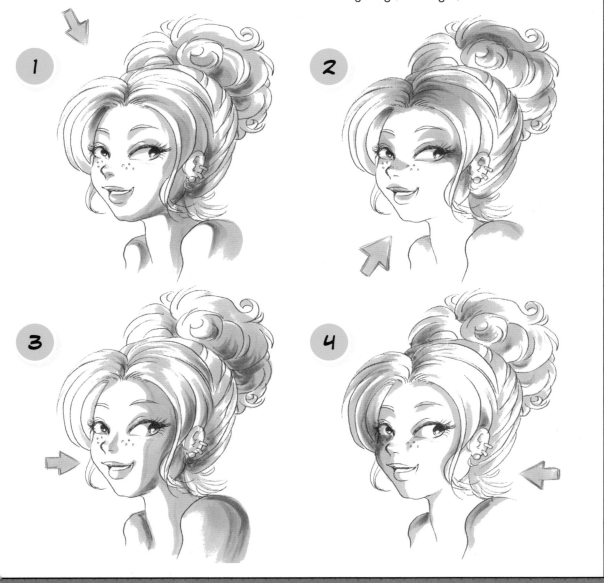

Add shading to these objects, experimenting with different light directions

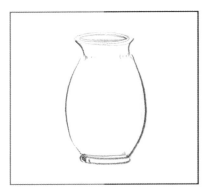

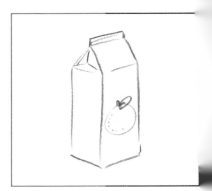

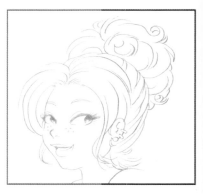

TONAL PATTERNS

Before home computers, there was no way to generate background patterns other than by hand. From the late 1960s to the 1990s, thin, transparent tone sheets were applied to artwork to create shadow and patterns in black-and-white comics. These tone sheets were clear, thin pieces of plastic with sticky backs that had mechanically generated patterns printed onto them in black ink. The artists would cut out an area of tone, stick it to the piece of art, and then cut away the excess.

Today, tones can be generated using software, and many manga artists add shading digitally by placing tone where required. Different tones can give different effects. Here are some renders of tone from digital programs.

A PATTERN OF TONE CAN ALSO BE MADE UP OF WHITE DOTS SET ONTO BLACK; THIS IS OFTEN USED FOR FLASHBACK IMAGERY.

TONE DOESN'T HAVE TO BE IN BLACK AND WHITE—SOMETIMES TONE IS IN COLOR WITH A LIMITED PALETTE, FOR A MORE POP-ART VIBE.

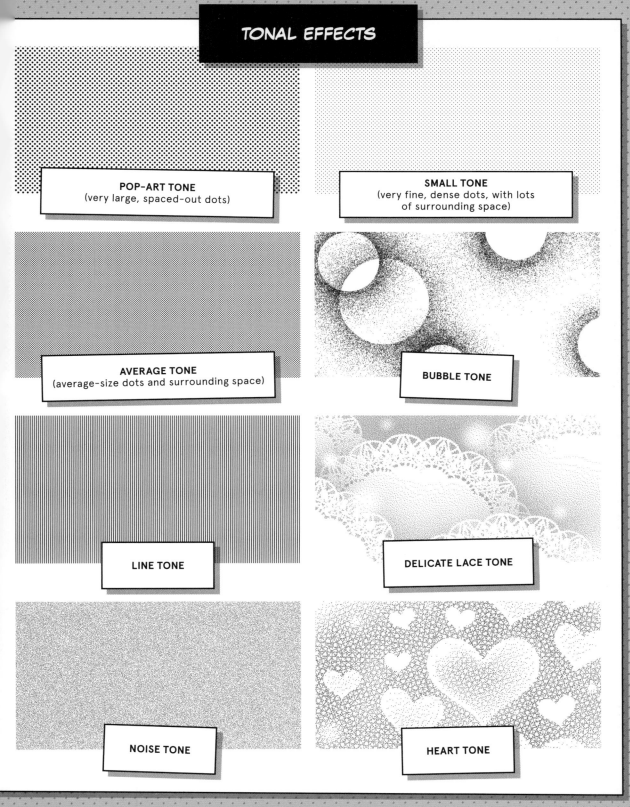

TONAL EFFECTS

POP-ART TONE
(very large, spaced-out dots)

SMALL TONE
(very fine, dense dots, with lots
of surrounding space)

AVERAGE TONE
(average-size dots and surrounding space)

BUBBLE TONE

LINE TONE

DELICATE LACE TONE

NOISE TONE

HEART TONE

TELL THE STORY

COMIC PAGE STRUCTURE

In the last chapter we looked at how to compose scenes within a panel. Here are some things to take into consideration when mapping out the structure of your panels.

It is useful to think of your panels from the point of view of a camera operator, or as if you are watching a show on a TV screen. When choosing how to draw the contents of your panel, think about how you might display the scene on a screen.

IF YOUR MANGA HAS A BIG CAST, YOU MAY WISH TO DRAW ON LARGE PAPER SIZES TO ENSURE EVERYBODY FITS INTO YOUR PANELS. YOU CAN THEN SHRINK DOWN THE WORK WHEN YOU PHOTOCOPY IT OR SCAN DIRECTLY INTO YOUR COMPUTER.

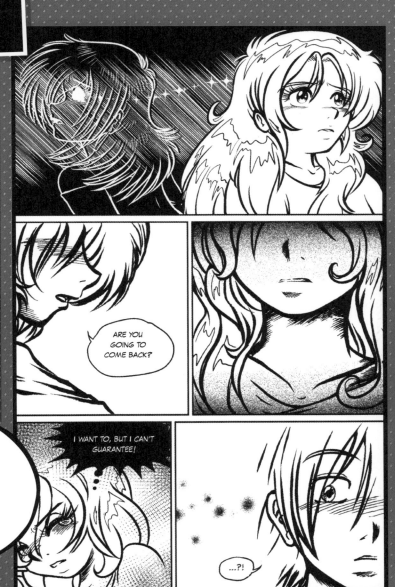

STRUCTURING PANELS

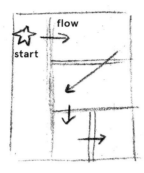

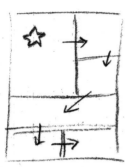

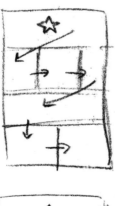

- **Panels**—An illustrated scene surrounded by a box.

- **Splash panels**—Large establishing scenes; they take up an entire page and are usually shots of a particularly dynamic action or event.

- **Panel gutters**—The spaces between the borders of the panels. For comics that are read horizontally (rather than vertically) the panel gutters are thicker above and below a row of panels than the vertical gutters separating them. This helps the reader to read in the desired direction, as the reader's eyes will skip over thinner vertical gutters more quickly.

- **Panel flow**—When reading an English manga left to right, the page flow starts at the top left and flows downward, exactly the same as reading a text-only book. Each comic page on average hosts anything between three and eight panels.

- **The 180 rule**—This is not a strict rule, but it's something to consider. The rule is to maintain the same left/right relationship between characters throughout a scene, and not suddenly flip their positions around. Otherwise, it can be very confusing, especially if similar-looking characters appear in the same panel, or on the same page.

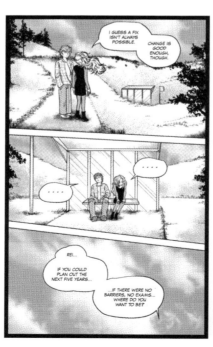

4-KOMA

In Japan, daily newspapers often feature four-panel comic strips, known as "4-koma." The four panels are read vertically, as Japanese is read from top to bottom. In English-language newspapers and magazines, comics tend to run horizontally.

1. Fold a piece of paper in half lengthwise.

2. Draw four equidistant panel borders down the folded page.

3. Add in dialogue and speech bubbles in pencil, then draw your characters and scenery. When you are happy with it, add ink using a thin-nibbed pen.

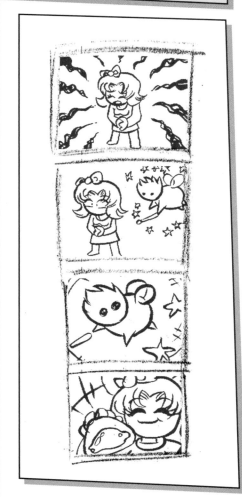

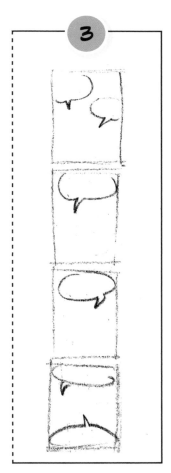

MAKING COMIC BOOKS

When you have a story ready, you may want to turn it into a physical comic book to sell at conventions or online.

If you're just starting out, I recommend beginning with a small comic. This can feel less daunting and you can draw simpler, faster illustrations. Then you can make bigger comics confidently.

You can create a small comic book using just a single piece of paper. This simple method gives you an immediate, finished result. The instructions in this section relate to pages that are read from left to right, as in English, as opposed to Japanese comics that are read from right to left.

THIS FORMAT IS PERFECT FOR CUTE ILLUSTRATION COLLECTIONS, JOKE COMICS, AND SHORT STORIES. IT IS A CHEAP AND EASY WAY TO INTRODUCE YOUR WORK TO NEW AUDIENCES.

HOW TO MAKE AN 8-PAGE COMIC BOOK

Here are instructions for making a simple eight-page comic book using a single sheet of paper:

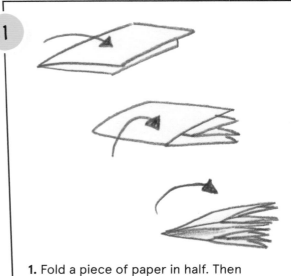

1. Fold a piece of paper in half. Then fold again, and once more.

2. Unfold the paper. You will see the piece of paper has been creased into eight sections.

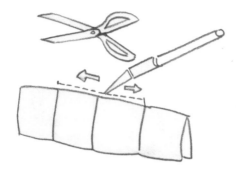

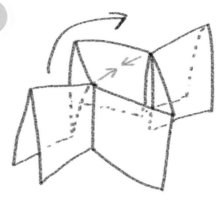

3. Holding your paper landscape, use scissors or a craft knife to cut along the crease between the middle four sections—not all the way across, only the two middle sections.

4. Fold the paper in half lengthwise, then push both ends of the paper inward, so that an opening forms where the crease was cut. Fold the paper in on itself to create a booklet.

5. Number the pages from 1 to 8—the "front cover" is your first page. Unfold the piece of paper, and you are ready to draw your comic.

THIS COMIC CAN EASILY BE REPRODUCED BY PHOTOCOPYING THE ORIGINAL, THEN FOLLOWING THE STEPS AS BEFORE TO CREATE A NEW BOOKLET.

PAGINATION

The best way to learn how the pagination process works when making comics for print is to make a draft comic book—a test proof—before you draw your manga and print out loads of copies.

This example is for 16 pages, a good length for a first chapter. This will also help you make a proof of your comic if you are working manually (not digitally). If you want to make your comic longer than 16 pages, use multiples of four.

1

1. Take four pieces of blank paper and align them neatly in a stack. Fold the stack in half, number the pages, and then dismantle the proof.

2

| 16 | 1 | | 2 | 15 | | 14 | 3 |

| 4 | 13 | | 12 | 5 | | 6 | 11 |

| 10 | 7 | | 8 | 9 |

DON'T FORGET TO CREATE A FRONT AND BACK COVER, AND CONSIDER INCLUDING THE FOLLOWING IN YOUR BOOK: 4-KOMA STRIPS, SPLASH PAGE ILLUSTRATIONS, AND ADVERTISEMENTS FOR YOUR OTHER STORIES OR YOUR FRIENDS' COMICS THAT YOU MAY WISH TO TELL YOUR READERS ABOUT.

2. You can now see how your comic's pages will need to be sequenced for print. You can then scan each of your double-page spreads, then create one master file to print off at home or send to a professional printer.

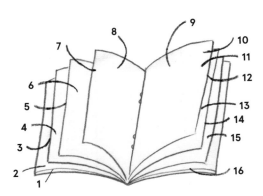

3. You can now print your comic double-sided, and assemble the pages in order, ready to staple. Your pages can be printed on any color paper—consider your budget and any story/art requirements. A color front cover is a nice addition and is very eye-catching (see page 148).

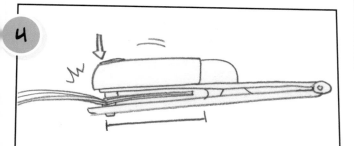

4. Staple your comic together, making sure your front cover is on top. It's neater (and a bit safer) to have the prongs of staples on the inside of your book.

It can be very daunting entering competitions straight away, so make your own comics for fun first. However, entering manga competitions is a good way to get used to some of the formalities and technical specifications of creating comics ready for print. It can also be incredibly rewarding!

More detailed information about entering competitions can be found online; here are some examples to look up:

- Silent Manga Audition Competition
- Clip Studio Paint Illustration Contest
- MediBang Paint Art Contest
- JUMP PAINT Global Artistic Manga Award
- 2000AD Portfolio Competition
- Manga Jiman Competition (UK)
- Observer/Jonathan Cape/ Comica Graphic Short Story Prize (UK)

DRAFTS

Sketching out your manga in thumbnail form is a great way to plan your comics. Thumbnails are very small, quick sketches of the pages in your manga story.

It's best to make thumbnail sketches at very early stages, when it's easier to make revisions. Drawing quickly allows you to get all of your ideas down on paper faster, without taking too long on each panel, so you don't forget what you were going to draw in the next.

CREATING THUMBNAILS

Thumbnail sketches are like bullet points, but in drawing form, to help get the gist of the story across and enable you to discuss it with your peers more immediately.

To begin, draw multiple double-page spreads—sets of two pages that would be viewed together—on a piece of paper (or use a computer to draw boxes on a page and print this out). Leave some space underneath each box for writing notes. You could also draw arrows to show the direction of your intended page and panel flow—this is especially useful if you are working with another artist, or if you want to discuss your work with someone else.

EVEN IF YOU DON'T THINK MUCH OF YOUR PAGES, USE SOCIAL MEDIA TO GET YOUR WORKS IN PROGRESS OUT WHEN YOU CAN. PEOPLE WILL OFTEN OFFER HELP IF YOU NEED IT, AND SEEING YOUR WORK ON-SCREEN CAN HELP HIGHLIGHT ANY ERRORS.

Rough character drafts, smiley faces with no detail, directional arrows, and blobs with "building" or "car" written in them are perfectly acceptable at this stage! Also avoid writing too many full sentences; boxes of text take longer to comprehend than visual images, so small drawings are best for clear and coherent thumbnails. The core aim of this task is to plan a story and put it down on paper as quickly as possible so that you don't lose steam early on.

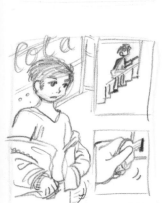

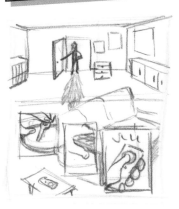

PANEL DRAFTING

For panel drafting, sticky notes are good because you can swap them around, remove them, or add in new plot points to adjust the length of your story or modify your storyline. You can edit a sequence easily without having to redraw any panels. Of course, if you have made panel drafts in a sketchbook, you can always cut out your panels and glue them down in a different order, if necessary (or simply number them in a different order). These are only rough drafts after all, so do what you want with them!

SHORT STORY STRUCTURE

Short stories are harder to create than longer narratives, but they can help you refine your skills. The key is to focus on the beginning, middle, and end of each tale.

Each short story can be printed as a small booklet, then when you have a number ready, you could compile them into an anthology in print.

1. **Beginning**—Establish characters (not too many to begin with!), scenes, and motivation.

2. **Middle**—Progression of the story. Insert a conundrum.

3. **End**—Satisfactory solution to the conundrum, or a twist ending.

WHAT IS YOUR FAVORITE HOBBY? YOUR FAVORITE SPORT? FAVORITE STUDY SUBJECT? FAVORITE FILM GENRE? CONSTRUCTING STORIES FROM THE THINGS THAT INSPIRE YOU WILL MAKE FOR ENGAGING AND EXCITING READING.

SUPPORTING ILLUSTRATIONS

In industry terms, illustrations that can be used to support and market your manga story are often referred to as "assets." These are important for any series, and can be a fun way to experiment with your characters outside of a story format.

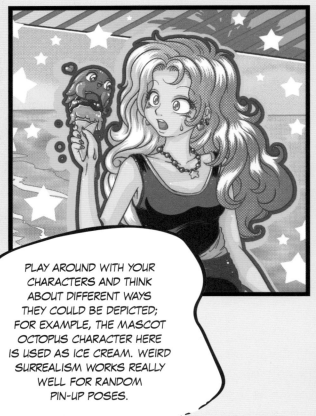

PLAY AROUND WITH YOUR CHARACTERS AND THINK ABOUT DIFFERENT WAYS THEY COULD BE DEPICTED; FOR EXAMPLE, THE MASCOT OCTOPUS CHARACTER HERE IS USED AS ICE CREAM. WEIRD SURREALISM WORKS REALLY WELL FOR RANDOM PIN-UP POSES.

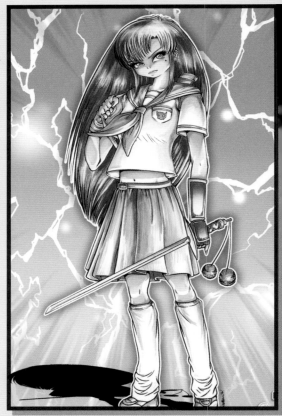

DESIGN TIPS

Here are a few classic supporting illustration ideas that you could try out:

- **A trio of characters**—draw shapes, such as triangles, and add characters at the points of the shape.

- **Portrait poses** of the main character(s), and/or the focus of the story (like a love interest).

- **Characters posed in scenes of daily life**— even if your story is in a completely different genre, this can work. It can be amusing to see science-fiction characters in a contemporary setting, a fun "parallel universe"!

- **Surrealism**—characters in different contexts are eye-catching and make the audience think a little bit more outside the focus of the story.

REMEMBER TO USE THICKER LINES FOR CHARACTERS IN THE FOREGROUND AND THINNER LINES FOR CHARACTERS IN THE BACKGROUND.

PHOTO PORTRAIT

FOREGROUND/ BACKGROUND

ABSTRACT TRIO

SMALL, MEDIUM, LARGE

ABSTRACT PAIR

LINEUP

FRONT COVERS

While supporting illustrations can be a bit more wacky, front covers are the first thing a potential reader sees, so these illustrations should be more straightforward to advertise the content of your work.

Here are some cover element suggestions to implement on your own front covers.

> FAMOUS MOVIE POSTERS CAN PROVIDE GREAT INSPIRATION FOR COVER DESIGNS, THOUGH REMEMBER TO FUSE YOUR INSPIRATIONS WITH YOUR OWN IDEAS INSTEAD OF COPYING OUTRIGHT. COMBINING ELEMENTS FROM DIFFERENT POSTER DESIGNS WILL MAKE FOR AN ORIGINAL COVER.

1. Logo, name, and URL of your brand.

2. Brand and series title appear at the top, because when comic books are stacked up on shelves, often only the top of each book is seen.

3. Series title.

4. Subtitle of series (this issue is the prologue chapter to my third book of this series).

5. Issue or chapter number, plus the price of this issue in your country.

6. Credit for your hard work. Several creators may be named and listed if your comic is a group project (for instance, if artist and writer names are required).

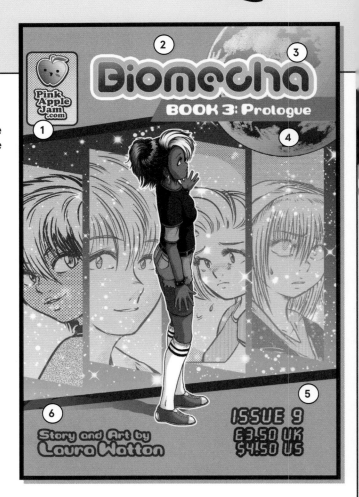

DESIGN TIPS

Here are some tips for a successful cover design:

- Box out your logo and your comic book brand—this usually sits in the top left of the front cover. This is a design specification for magazines or comic books that are advertised in racks; the title should be very visible so the customer sees it immediately.

- The focal point of the artwork should fit in the lower two-thirds of the page. The drawing should sit within a square, so it fits in between the header and footer. Square images are also the universal format to use on social media.

- The main character(s) of your comic should always be the focus of your cover, or if you have a big cast, they can appear in rotation per issue.

CREATING A COVER

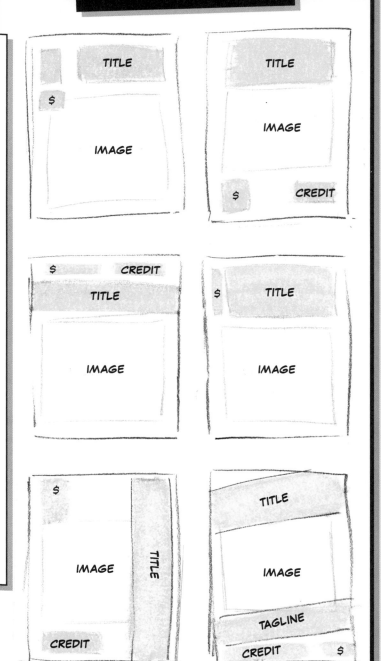

FRONT COVER ARTWORKS

Here's a step-by-step tutorial for creating a color illustration that can be used for a front cover:

1. Use a non-photo blue pencil to create a loose draft sketch.

2. Next, lay a clean piece of photocopier paper on top of the loose sketch and trace the lines with a pencil. It is easier to trace on top if you have access to a lightbox. You can buy a lightbox from an art store or online, but even a glass coffee table with a lamp underneath will do! The draft blue sketch should be made quickly and relatively roughly, but for this layer, the lines should be stronger and cleaner, with defined black pencil lines.

3. Add in some extra details very lightly, and you will start to see your character form.

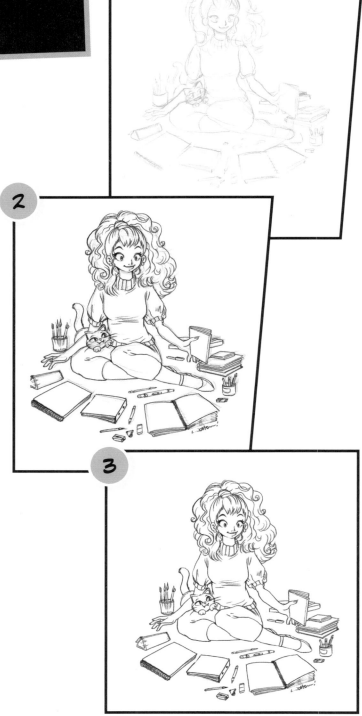

4. Finally, add color using rubber-tipped, alcohol-based markers. The main colors used here are a range of skin tones, violets, and blues. Lighter colors were applied first, then layered with darker tones of the same color.

Once finished, the final illustration can be scanned and presented as a PNG file, with the background erased using a digital editing program. PNG and TIFF files are good formats for print—they don't contain artifacts (digital speckles that can be found in JPEGs, for example), and always scan at a minimum of 300dpi (dots per inch) for a print-quality resolution. (See Glossary on page 156.)

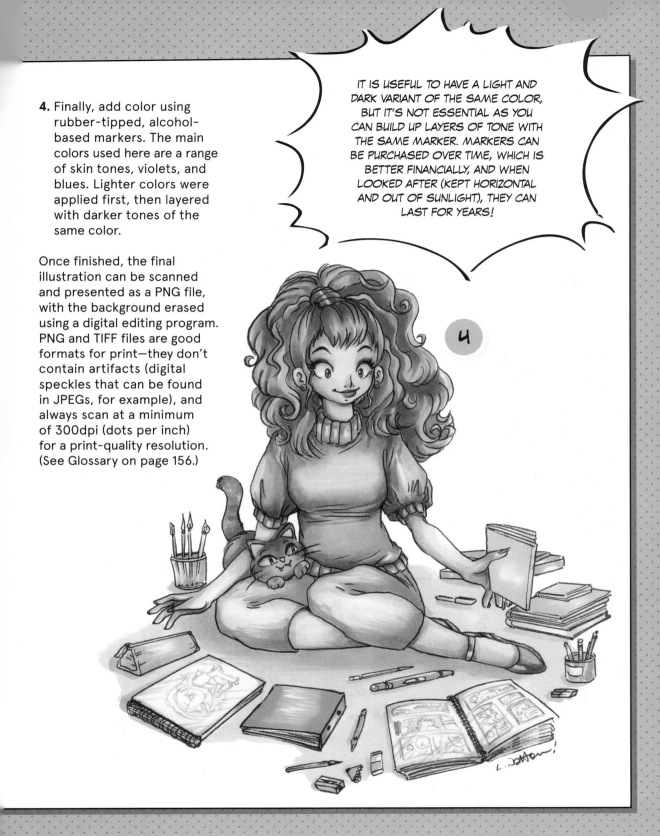

IT IS USEFUL TO HAVE A LIGHT AND DARK VARIANT OF THE SAME COLOR, BUT IT'S NOT ESSENTIAL AS YOU CAN BUILD UP LAYERS OF TONE WITH THE SAME MARKER. MARKERS CAN BE PURCHASED OVER TIME, WHICH IS BETTER FINANCIALLY, AND WHEN LOOKED AFTER (KEPT HORIZONTAL AND OUT OF SUNLIGHT), THEY CAN LAST FOR YEARS!

TROUBLESHOOTING

Sometimes readers can be confused when reading comics if scenes are not set out correctly, or if speech bubbles are out of order. Here are some common errors to avoid when creating manga.

Crossover of bubble tails—Speech bubble tails should be clean and short, with no confusing crossovers.

Illogical line weights—When characters appear in the foreground, the outlines of the character (outline of body, face, hair silhouette, nose, etc.) should be thicker to show that they are closer to the viewer. Objects that are farther away should be rendered in thinner ink lines to show their distance from the viewer.

Illogical bubble order—The first speaker's speech bubble should appear at the top left of the panel (for English-language comics). The next speaker's bubble should sit directly below or opposite it.

Cramped panels—If a scene is to depict a number of actions, they can't all be shown in one panel. This is especially important if a character changes mood, moves to attack, or reacts. The script needs to pay special attention to movement and key frames. Key frames are the main poses that you need to show to convey exactly what is happening step by step to make the action clear to the viewer.

SOLVING CRAMPED PANELS

Problem—Here is an example of two scripted scenes that cannot be depicted in single panels because multiple actions are happening that need to be shown in separate steps:

- Panel 1—Character picks up bat, prepares to strike, hits piñata
- Panel 2—Piñata explodes, character celebrates releasing the candy, children celebrate

Solution 2—Here is an example of the key frames reduced to core actions; this is especially important if the scene is not vital and you are working to a page count limit:

- Panel 1—Character wields bat
- Panel 2—Character hits piñata
- Panel 3—Everyone celebrates the falling candy (large panel)

Solution 1—This example describes a number of actions that really need a panel each to work. So, expand the number of panels, or cut out the number of specific actions required at the scripting stage. Here's how you could expand the script to allow for a panel per action:

- Panel 1—Character picks up bat
- Panel 2—Character prepares to strike
- Panel 3—Character in process of hitting, whirling bat through the air toward the piñata
- Panel 4—Character hits piñata— successful contact!
- Panel 5—Candy falls out
- Panel 6—Character celebrates obtaining the candy with a dance
- Panel 7—Character looks over their shoulder to see other children celebrating
- Panel 8—Everyone celebrates with the candy

THIS EXAMPLE WOULD FIT NICELY ON ONE PAGE. IT EXPLAINS WHAT'S HAPPENING WITHOUT BEING OVERLY STRETCHED OUT, WITH PLENTY OF ROOM FOR THE ARTIST TO CREATE A DYNAMIC SET OF PANELS.

THIS EXAMPLE WOULD WORK BEST OVER TWO COMIC PAGES, WITH FOUR PANELS ON EACH PAGE, OF WHICH THE ACTION PANELS ARE THE LARGEST.

TIPS

I want to get my comic published. Should I draw it from right to left or from left to right? Comics are generally drawn using the conventional reading flow of the country in which it is produced. For reference, Korean, Thai, and English-language comics are read from left to right, while Chinese and Japanese comics are read from right to left.

At one time, Western publishers would flip Japanese comic pages to read from left to right as per Western reading conventions. However, in the past two decades or so, it has become common for publishers to leave translations unflipped as it turned out that audiences were easily able to adjust their reading styles to read Japanese manga.

Most publishers prefer submissions of English-language comics to read from left to right, and it is often stated in submission or competition guidelines what is preferred. Always check to see if the publisher has a preference before submitting to them.

If you are self-publishing, draw however you want to draw—you are your own boss!

Creating manga is an art that takes up a lot of personal time! Try not to be put off by others who haven't tried making a comic themselves. As with other artistic hobbies, making manga takes vast amounts of time, care, and skill—you wouldn't make a sweater for someone who didn't appreciate the effort behind the craft.

Appreciating constructive criticism is tough, but even if it sounds harsh at first, it may help you in the long run, especially if it comes from someone you trust who has taken the time to study your work.

Build your own website to make a good impression—don't rely on third-party sites to stand in for a professional gallery.

Take influence from all forms of art to inform your own style—from Japanese comics to European comics, from architectural styles to spaceship designs, and so on.

Life drawing is a must. If you can join life drawing classes, it will improve your artwork. Look for your nearest available courses; your local colleges and community centers will have contacts.

IF YOU KEEP SAYING HOW AWFUL YOUR ARTWORK IS, OR THAT YOUR STORY IS BAD, YOU MAY NEVER FINISH YOUR COMIC. IF YOU'RE STARTING OUT, RELAX. NOBODY IS EXPECTING WORLD-CHANGING WORK FROM ANYONE'S FIRST ATTEMPTS! WE ALL HAVE TO START FROM SOMEWHERE.

Learn how to draw two-point and three-point perspectives. These are great devices for drawing comic panels that make the reader feel like they are right there.

Using references is not copying. This is fine for learning manga forms and structures. But be sure to personalize your comic pages, and make them your own. Don't try to pass off a direct copy of anyone else's artwork as your own—the internet knows all and "art thieves" do get found out!

Set goals. What do you wish to gain from your work? Do you want to make comics for fun only? As a serious hobby? Or as a career? Different factors will be bigger sources of drive and motivation for some than for others; everyone works differently. It's good to have an aim, so think hard about why you want to make manga, and focus on how you can make your comics as good as you can!

When writing manga, ask yourself, "What is the point of this story?" Or rather, "What's this story about?" If you write a short story that's half about "finding yourself" and half about "the inevitable fall of capitalist society," you may end up with one big mess (unless you have a really good twist!). Start with one or the other, then you can develop your narrative as you go forward.

DRAW FAN ART (ART BASED ON YOUR FAVORITE CHARACTERS AND SHOWS) TO TEST OUT NEW TECHNIQUES! YOU CAN HAVE FUN AND BE PRODUCTIVE AT THE SAME TIME. BY SHARING YOUR WORK, YOU MAY EVEN MAKE NEW ARTIST FRIENDS WHO LOVE THE SAME SHOWS AS YOU DO.

Quality matters. Take care of your comics! Most people won't care about your work if it looks like you didn't care about it in the first place. So use straight and triangle rulers, and correction fluid for clean lines, and carry your art around in protective cases to help with presentation—these things matter in the long run.

Every step counts. Every artist will tell you that with each comic you make, you will get better. Completing a short and self-contained story will bring you satisfaction and give you the motivation to go further and make even better comics. When you look back, you will be able to take pleasure from seeing how you've improved.

Whatever you learn can be applied to your next comic! Every project is a valuable learning experience.

USEFUL RESOURCES

ONLINE RESOURCES

Online comic hosts:
The Duck Webcomics, Smack Jeeves, Gumroad, and Tapas

Online stores where you can sell your comics:
Etsy, Gumroad, and Shopify

Make-your-own website companies:
Wix and Squarespace

Online comic printers:
Comic Printing UK, UK Comics Creative, Comics2Print, Mixam, printninja.com, printingcenterusa.com, and ka-blam.com

Online galleries:
DeviantArt, Tumblr, and Instagram

ART RESOURCES

Natural media brands:
Copic, Letraset, Deleter, Pigma Micron, Kuretake, Pilot, and Pentel

Digital software:
Adobe Elements, Adobe Photoshop, eFrontier, Clip Studio Paint, FireAlpaca, and Paint Tool SAI

Digital fonts and lettering:
Blambot and Comicraft

Digital image collections:
iStock, Shutterstock, Getty, Google Images, Flickr, and Photobucket

Please be aware of copyright restrictions where relevant.

INSPIRATION

Eiichiro Oda—*One Piece*

Masashi Kishimoto—*Naruto*

Osamu Tezuka—*Astro Boy (Tetsuwan Atom)*

Hirohiko Araki—*JoJo's Bizarre Adventure*

Naoko Takeuchi—*Sailor Moon*

Junji Ito—*Spiral, Cat Diary*

Leiji Matsumoto—*Captain Harlock*

Shirow Masamune—*Ghost in the Shell*

Ai Yazawa—*Paradise Kiss*

Yuu Watase—*Fushigi Yûgi*

Tite Kubo—*Bleach*

Kōhei Horikoshi—*My Hero Academia*

Riyoko Ikeda—*The Rose of Versailles (Berusaiyu no Bara)*

CLAMP (group): Nanase Ohkawa, Mokona, Tsubaki Nekoi, Satsuki Igarashi—*X/1999, Cardcaptor Sakura*

Junko Mizuno—*Cinderalla*

Yukito Kishiro—*Battle Angel Alita*

Masakazu Katsura—*Video Girl Ai, Tiger & Bunny*

Tony Valente—*Radiant*

Felipe Smith—*Peepo Choo, MBQ*

Konami Kanata—*Chi's Sweet Home*

Moto Hagio—*A Drunken Dream and Other Stories*

RECOMMENDED READING

Some of these books are out of print, but they may be available via secondhand sellers. These books have been pivotal for my understanding of sequential art and Japanese pop culture, and they are staples from my personal collection.

1,000 Ideas by 100 Manga Artists
Compiled by Cristian Campos
(1,000 tips on techniques, inspiration, and ways to build up your manga portfolio)

Even a Monkey Can Draw Manga!
by Koji Aihara and Kentaro Takekuma
(Hilarious mock-instructional comic book narrative)

Framed Ink
by Marcos Mateu-Mestre
(A practical guide to composition)

FRUiTS
by Shoichi Aoki
(A collection of Tokyo street fashion portraits)

Mangaka America
Compiled by SteelRiver Studio
(A guide to American manga)

Manga! Manga! The World of Japanese Comics
by Frederik L. Schodt
(The "manga bible," first published in 1983)

Manga in America
by Casey Brienza
(On the domestication of Japanese manga in America)

The Animator's Survival Kit
by Richard Williams
(Covers all types of animation art)

Understanding Comics: The Invisible Art
by Scott McCloud
(Best-selling book on storytelling and visual communication)

Making Comics
by Scott McCloud
(Follow-up book to *Understanding Comics*)

Moyoco Anno is a mangaka who has had a vast number of titles translated into English. Her popular series for young women include *Happy Mania* and *Sakuran*, as well as stories for young girls such as *Sugar Sugar Rune*. Her style is loose and energetic.

Akira Toriyama created *Dragon Ball* and followed up with *Dragon Ball Z*. Massively popular in Japan and Europe, the series was initially inspired by *Journey to the West*, a classic Chinese novel.

Rumiko Takahashi is Japan's most prominent female manga artist. Her work has influenced many artists, especially in the West, as her fantastic stories have universal appeal. Takahashi's stories were some of the first to be translated outside of Japan in the late 1980s and early 1990s.

Katsuhiro Otomo created the first huge anime hit that was specifically promoted as uniquely Japanese in the West in the early 1990s, *Akira*. A cyberpunk sensation, his style was influenced by a number of European artists.

GLOSSARY

anime—Japanese-produced animation. Most anime is based on a preexisting manga, or a light novel. "Anime" is a shorthand loan word from the Western word "animation."

doujinshi—Self-published comic books by artists of all skill sets. Amateur, semi-pro, and fully pro artists sell doujinshi at Japan's biggest biannual comic market, Comiket (Comic Market).

DPI (dots per inch)—This is a measure of the resolution of digital images. The higher the DPI, the higher the density of dots and the higher the image quality—but the bigger the file size. 300–600dpi is good for printed color images, and 600–1,200dpi for printed black-and-white line art. This is because black-and-white artwork looks better with higher resolution; in color, there is more information in the image so line clarity is not as necessary.

GSM (grams per square meter)—This is a measure of the weight of paper. Photocopier paper is usually 80 or 90gsm. Thicker, heavier sheets, which are better for painting, are in the hundreds.

josei—Comics aimed at female audiences.

kodomo—Comics aimed at very young children, often with TV and toy licensing.

light novels—Popular short-form fiction aimed at a young demographic.